colored pencil
COLLAGE

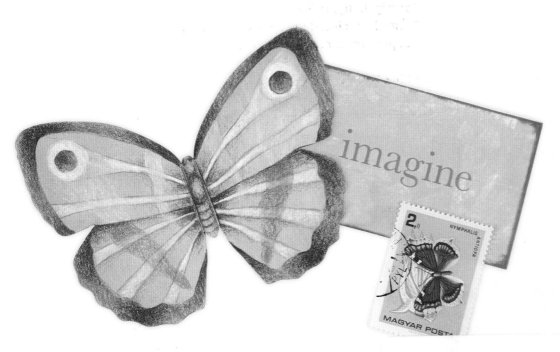

lachrymose ('ri-mōs), *adj.* tearful; sad.

lacing (lās'ing), *n.* action of one that laces; braid of a uniform; a rope through the eyelet of a sail; colored border of a flower; a shoestring; metal clip to unite ends of belts; segment of a leaf; [Slang], a dash of spirits in a beverage; a sound thrashing.

lack (lak), *v.t.* to be destitute of; *v.i.* to be in need; to be deficient; come short: *n.* want; failure; famine.

lackadaisical (-ā-dā'zi-kal), *adj.* affectedly pensive or sentimental.

lackey ('i), *n.* a menial attendant; footman: *v.t.* to wait upon, as a lackey; act servilely.

laconic (lā-kon'ik), *adj.* expressing in few words.

laconically (-kal-i), *adv.* briefly.

lacquer (lak'ēr), *n.* a varnish consisting of shellac dissolved in alcohol and variously colored: *v.t.* to varnish with lacquer.

lacrosse (lā-krôs'), *n.* a Canadian game of Indian origin, played with a ball and a bat called a *crosse*.

lactarine ...

lactate ...

lactation ... the act or period of suckling.

lacteal (lak'tē-al), *adj.* pertaining to milk; conveying chyle: *n.* one of the lymphatic vessels that convey chyle from the intestines to the thoracic duct.

lactescence (-tes'ens), *n.* a milk-like appearance.

lactescent (-ent), *adj.* having a milky appearance.

lacti-, lacto-, combining forms from Latin *lac*, milk.

lacticinia (lak-ti-sin'i-ā), *n.* food consisting of, or prepared from, milk, forbidden by Roman Catholics on fast days.

lactiferous (-tif'er-us), *adj.* producing or conveying milk.

lactigenous (lak-tij'e-nus), *adj.* producing the flow of milk.

lactochrome (lak'tō-krōm), *n.* a yellow substance, said to be present in milk.

lactocrite (lak'tō-krīt), *n.* an instrument for separating fatty matter from milk to determine its proportion.

lactoglobulin ..., *n.* a protein or albumen ...

lactometer (-tom'e-ter), *n.* an instrument for ascertaining the specific gravity of milk.

lactoprotein (lak-tō-prō'te-in), *n.* one of the several proteins or nitrogenous compounds that occur in milk.

lactose (-tōs), *n.* a hard, white sugar present in milk.

lactosuria (lak-to-sū'ri-ā), *n.* a condition caused by lactose in the urine.

lactucarium (lak-tu-kā'ri-um), *n.* the inspissated juice of lettuce; sometimes used in place of opium.

lacuna ... blank ...

lacustrine ... growing ...

lad (lad), *n.* ...

ladder ('ēr), *n.* a framework consisting of two parallel side pieces connected by bars, etc., forming steps at suitable distances; anything by which one climbs or ascends.

laddie ('i), *n.* [Scotch], a lad.

lade (lād), *v.t.* to load, freight; heave or throw out.

Ladies from Hell (Ladies ...), Scottish Highlanders, who served in ... World War ... kilts: at first, they were known ... Watch, afterwards as ...

lading ('ing), *n.* the act ...

ladle ('l), *n.* a deep spoon ...: *v.t.* to dip up with a ladle.

ladrone (lā-drōn'), *n.* a robber, bandit; ...

lady (lā'di), *n.* ... the wife of a knight; the mistress of a house; ...

ladybird ... insect ...

ladybug ...

lady-killer (-kil-ēr), *n.* a man with a ... for fascinating ...; a coxcomb.

lady-love (-luv), *n.* a sweetheart.

ladyship (-ship), *n.* the rank or title of a lady.

lag (lag), *v.i.* to move slowly; loiter; stay behind: *v.t.* ... to arrest, or put ...

laic ..., *adj.* pertaining to the laity; ...

lake ... a large body of water surrounded by land; a pigment of a dark red color prepared from cochineal.

colored pencil
COLLAGE

nature drawing and painting
for mixed media

kelly hoernig

NORTH LIGHT BOOKS
Cincinnati, Ohio
CreateMixedMedia.com

Contents

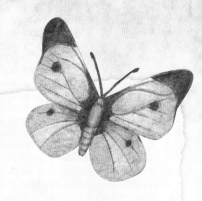

Supplies to Get Started

10" (25cm) square frame with 3½" (9cm) opening

12" (30cm) cake board

12" × 12" (30cm × 30cm) wooden board

12" × 6" × 2" (30cm × 15cm × 5cm) wood block, sanded and rounded at the corners

3 wooden spacers or scrap cardboard

6¾" × 5" (17cm × 13cm) oval wood shape

8" × 8" (20cm × 20cm) Masonite board

Adirondack Color Wash in Espresso

Archival Ink Pad in Coffee

art journal

assorted canvas panels

assorted paintbrushes

assorted papers

binder clips (6)

bingo card

black transfer paper

book pages

bristol board and cardboard scraps

Canson Mi-Teintes paper in Tobacco and Twilight

clear glue

Coffee Break Design bee tag C-169

collage elements

composition notebook

container of water

craft knife

Crayola Model Magic air-dry clay

cutting mat

DecoArt acrylic paint in Asphaltum, Base Flesh, Camel, Charcoal Grey, Colonial Green, Cool Neutral, Dark Chocolate, Desert Sand, Driftwood, Espresso, Fawn, Flesh Tone, French Vanilla, Gingerbread, Honey Brown, Ice Blue, Jade Green, Lilac, Mink Tan, Mississippi Mud, Sable Brown, Sea Glass, Shading Flesh, Soft Black, Terra Cotta, Toffee, Traditional Raw Umber, Warm Neutral, Wasabi Green, White, White Wash

DecoArt Faux Glazing Medium

dictionary pages

drywall tape

empty toilet paper roll

gesso, white and clear

Golden Light Molding Paste

Golden Regular Gel

kneaded eraser

Krylon Workable Fixatif

library cards

light-colored fabric with writing

makeup sponge

masking tape 1" (25mm) wide

matte medium

metal findings and cabinet knob

newspaper

painter's tape

palette knife

palette or palette paper

paper towels

pencil and sharpener

Prismacolor colored pencils in Aquamarine, Artichoke, Black, Black Cherry, Celadon Green, Chestnut, Chocolate, Cloud Blue, Cream, Crimson Lake, Dahlia Purple, Dark Brown, Dark Umber, Espresso, French Grey 20%, French Grey 70%, French Grey 90%, Ginger Root, Goldenrod, Green Ochre, Henna, Imperial Violet, Indigo Blue, Jade Green, Jasmine, Kelly Green, Kelp Green, Lemon Yellow, Light Umber, Limepeel, Mahogany Red, Muted Turquoise, Nectar, Pale Sage, Peach, Peach Beige, Sandbar Brown, Sap Green Light, Sepia, Sienna Brown, Slate Grey, White, Yellow Chartreuse, Yellow Ochre

puzzle piece

recycled book of your choice

recycled cheese box (e.g., President brie, Laughing Cow Swiss)

recycled cigar box

rubber stamps: alphabet, numbers, words

ruler

sandpaper

scissors

sea sponge

seed packet or envelope

spreader (e.g. hotel card, credit card)

stencils, variety

sticky notes

Strathmore mixed-media paper

stylus

Super Chacopaper transfer paper

table salt

texture items—bubble wrap, burlap, corrugated cardboard, spiral paper edging, plastic, fabric, paper, doilies, tulle

toothbrush

tweezers

twigs

watercolor paper

watercolor set

waxed paper

white eraser

white transfer paper

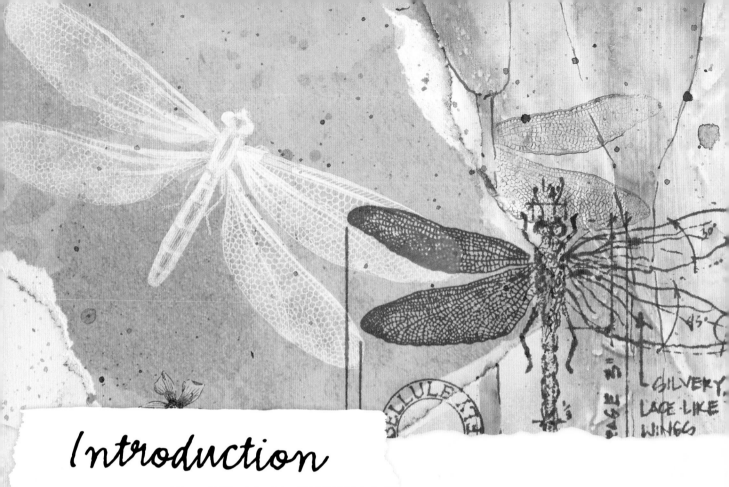

Introduction

Welcome to *Colored Pencil Collage!*

I am so happy to be bringing you this multi-media creation filled with inspiration at your fingertips. I hope it will set you on a journey of playing, experimenting and growing into the artist you would like to become.

It is an adventure and through step-by-steps, you will see changes and advancements in your art. You will start to fine-tune your color palette and the things you collect and add to your artwork. It all comes with practice and does not happen overnight. Be patient with yourself and explore every possibility with the wide-eyed innocence of having never done it before.

My journey has taken a lifetime, and I am still learning and honing my skills every single day. Being creative every day is something I must do. It comes to me in many forms whether painting, pencilling, writing or taking photographs. It doesn't matter as long as I do something each day to keep me on my toes and searching for my muse.

In this book I will help you explore materials, colored pencils, design skills and projects that build upon themselves as the book progresses. Flip through, find something that sparks your creativity and start there. There are no rules, just fun projects to get you thinking outside the box and into your collections.

For me, collage is about adding a personal touch or piece of myself to my artwork. Whether it shows up in the color palette, subject matter or the ephemera I add, it all comes down to what I like and what I want my finished art to say. By combining the things you collect, treasure and love, how can the art you create not be about you? It really can't, and that is the beauty behind collage work.

4

LIFE OF THE HIVE

Imagine you are a patient, curious alien, and you are hovering over a large Earth city in your spaceship. You see people scurrying to and fro on sidewalks, police officers blowing whistles and moving their hands, children dashing into classrooms, adults entering offices, hospitals, and stores. You wonder if there is any order to this chaos, and you are a patient, curious alien, and you observe that each person... Eventually you see

So it is with... a job to accomplish.

... hive... con for... ion of a

... se... mov... on... a

... n whic...

... dis-

... st like

... ontrols

... cientists

... eir different jobs;

... on't know why

... that the bees are

... eir lives for the good

... n about the jobs of

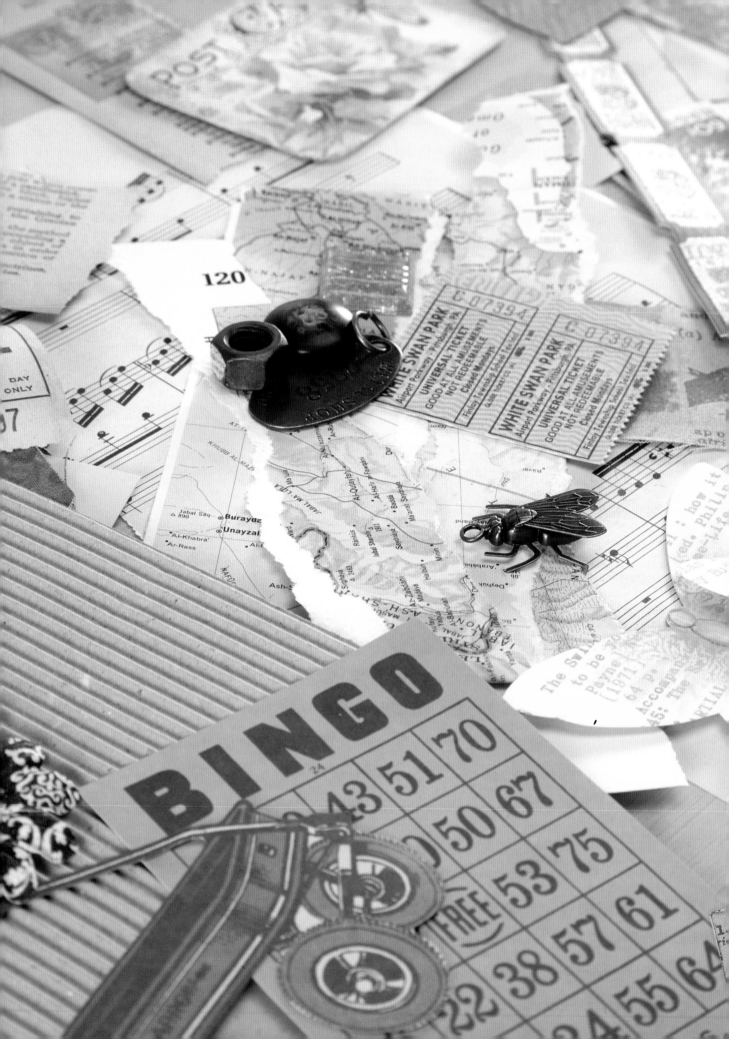

1 Materials

As we get started, I thought it would be nice to introduce you to a few of my favorite things and sources of inspiration. I find both invaluable to being an artist and hope they will help you discover what you really love along the way. From material basics, mediums and embellishments to outdoor treasures, collections and a reference library, how can we go wrong with what inspires us? We can't, and that's a great thing.

It takes time to build up a wealth of resources so start slowly. If you like nature, take a walk and pick up anything that piques your interest. If you like to shop, make note of color combinations or interesting textures. All of this will create a library for you to call upon when needed. Throughout these pages I will be sharing what I love, collect and embrace as my inspiration starters. Let them guide you to a creative jump start to finding you, the artist.

ma·te·ri·al || noun
1. the matter from which a thing is or can be made.
2. facts, information, or ideas for use in creating a book or other work.

Art Supplies

Materials are important to any craft, and once you become accustomed to how they work, you will be able to use them as you see fit. Here are some of my most-used art supplies for creating the projects in this book.

COLORED PENCILS

I use Prismacolor Premier Colored Pencils. I have learned to appreciate their soft wax core and know what I can and cannot do with them. There are now 150 colors to choose from, letting you create anything you can possibly imagine.

PAINT

I like DecoArt Americana Acrylics. I know how to mix colors but appreciate the convenience of it already being done for me. I love their matte finish and easy blendability. They are easily found in most craft and hobby stores.

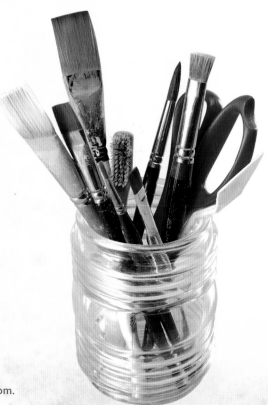

BRUSHES

I like Loew-Cornell brushes for fine details because their quality is long lasting and the brush tips do not break down. In fact, I have had some of my brushes for over ten years already.

The Simply Simmons brush line is great for doing collage work and is inexpensive, so there is less concern about damaging them.

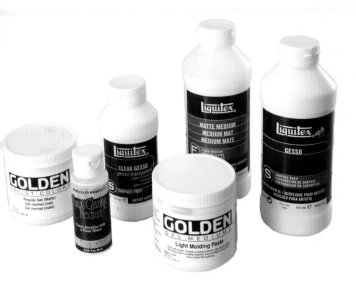

MEDIUMS

All mediums are not created equal. You have to find what you like and what works for the projects you create. Some are smoother while others have a grainy texture. In this book I used Golden and Liquitex products because I find they both work well with colored pencil and the techniques I have shared with you.

I also use DecoArt Faux Glazing Medium.

STENCILS AND TEXTURES

Stencils are a great way to add interesting elements without a lot of work on your end. I have a whole tote filled with my favorites.

Textures from found elements such as bubble wrap, tissue paper, burlap and doilies are also must-haves for any supply box. Pick and choose what you like and keep small pieces within arm's reach at all times.

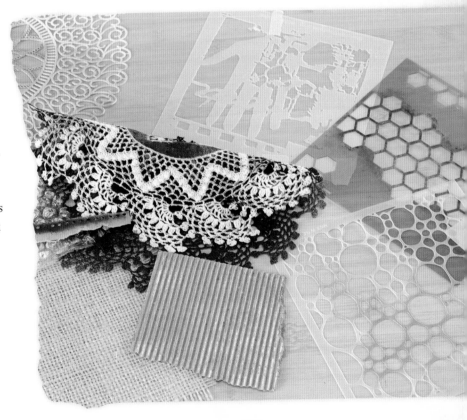

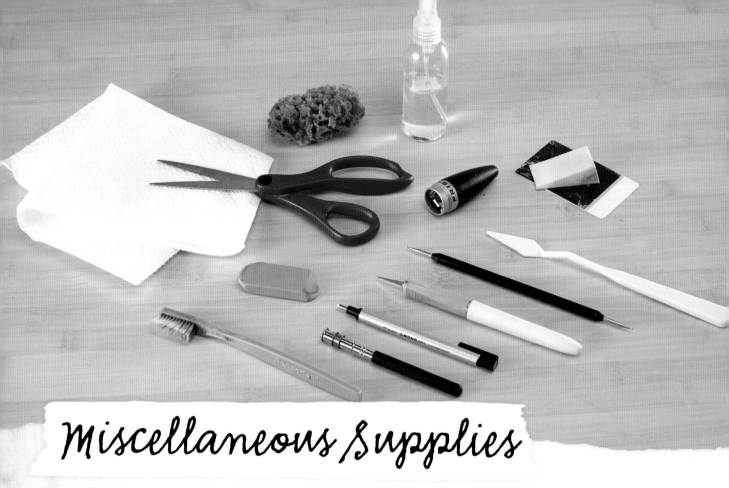

Miscellaneous Supplies

SURFACES

Surfaces vary from project to project, but I enjoy working on just about anything. Recycling and repurposing add a nice challenge, but paper availability can't be beat. Find what you like working on and stock up on it so you can create whenever inspiration strikes.

For the projects in this book we'll work on everything from wood and paper to fabric, canvases, old books and more.

ERASERS

I use a variety of erasers because they each serve a different purpose.

The kneaded is by far my favorite because of its gentle effects. This gummy, malleable eraser is meant to be kneaded, not stay in its package. The more you knead it, the more pliable it becomes, plus it becomes self-cleaning. You can shape this eraser, lift whole sections at a time or lighten your touch with just a bounce. To shape it, gently twist an amount between your fingertips until the shape you want appears. I also use this eraser to remove large sections by making it pliable and then flattening it. Place it on the unwanted area and press down firmly. When you lift it, you will see the wax on the eraser. This is exactly why I love this eraser. Now, knead it and watch the wax disappear. When the eraser gets too hard to pull, it is time for a new one.

I always have on hand a pink eraser, a black eraser for working on dark-colored surfaces and white erasers in various sizes and shapes. Adjustable white erasers can be found in small tip, medium tip and triangular tip holders. You can also find them in rectangular shapes. There are electric and battery-powered white erasers as well, but you need to use these with caution because they can damage the surface beyond repair if you're not careful. These are all usually found in the pencil/pen section of any office supply or art store. Add a kneaded, a white, a black, a pink and a battery-powered eraser to your supply box, and you will be set for any scenario.

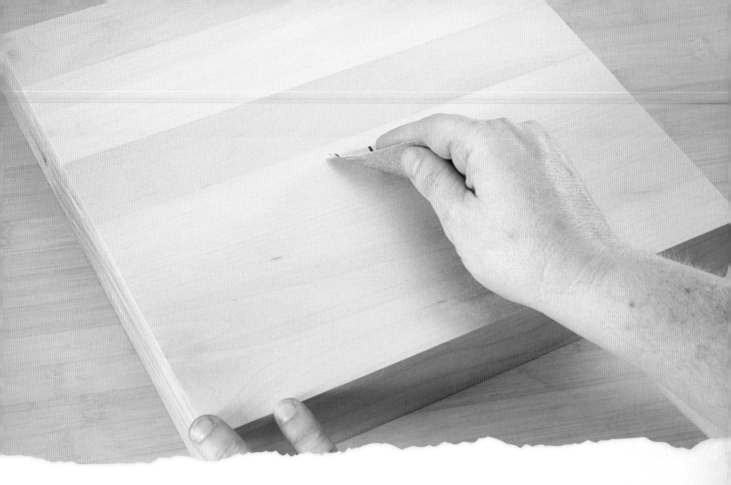

TAPE

I use drafting tape to hold my tracings down onto the prepared surface because it is extremely low tack tape. If you have only painter's tape, I would suggest sticking it to your clothes and pulling it away several times. This will put lint on the tape, making it less sticky.

SEALANT

For finishing my colored pencil work, I always use Krylon Workable Fixatif. This spray is like a varnish, but you can still work on top of it if necessary. When spraying I lay the art flat and spray over it, parallel to the surface, first in one direction, then the other. This allows the spray to lightly cover the surface without changing the background. I will do this until the whole surface is shiny. Once it is shiny, I will spray directly toward the finished art piece with a light layer. I change directions of the art with each spray and repeat this three times. Now it is ready to be mounted with a double mat and framed.

If you have only a section of colored pencil work, I would do the above step first, then spray with varnish to match the end results of the finished art. Light layers of varnish are better than heavy ones because they give a more even shine.

OTHER SUPPLIES

Pencil sharpeners are another must-have, and I actually prefer the Prismacolor handheld one. For the initial point, I use an electric sharpener, but from there on it is handheld.

I keep a variety of paintbrush alternatives nearby. I frequently use an old toothbrush, a natural sponge, a makeup sponge, an old hotel key and a palette knife to quickly spread gesso or paint or to create textures.

You'll also find it useful to keep paper towels, a spray bottle of water, a craft knife, a mechanical pencil and scissors on hand.

TRACING PAPER

I create my work on tracing paper mostly because I can cut it, move it and overlap it until I am happy with it. Plus it allows me to see through to the layers underneath. Once satisfied with my arrangement, I will then make a copy onto vellum. This allows it to be one piece of paper instead of a fragile state of tape, pencil and tracing paper. If you don't have a copier handy, you can transfer your drawing to a piece of vellum with a lightbox or your window. Just make sure to tape well before inking up your design.

Once the drawing is on the vellum, I transfer it to my working art piece. Transfer or graphite paper will work for this. These can be purchased in many colors. My favorites are black, white and a water-soluble blue called Super Chacopaper, but it also comes in gray, red, yellow and royal blue. You can create your own graphite paper by rubbing a graphite stick over tracing paper until solidly covered. Rub a paper towel over the surface until a nice uniform surface appears and it is ready to go.

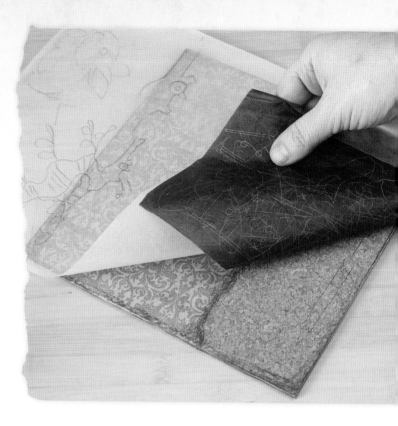

Transfer the design by placing the graphite side down on the surface and then tracing the design on top of the graphite paper. Lightly begin going over all of your lines. I use a stylus for this but a sharp pencil works well also. You want to check yourself when transferring to make sure the lines are not too heavy because they can be hard to get rid of. A light touch is always best. If you get too heavy, I suggest using a kneaded eraser lightly over the dark lines to lighten them.

Loew-Cornell transfer papers are highly recommended because they are easily erased without leaving a filmy residue on your art.

ARRANGING YOUR WORK STATION

It's useful if you spend a little bit of time arranging your work space before you get started. I'm right-handed so the arrangement to the left works best for me if it's situated to the right of my right hand. I keep my palette paper closest to my hand with a water container and paints next to it. I keep brushes farthest away because I don't want to reach over them to get to my paint or water.

Ephemera

Ephemera is something that I have been collecting for a couple of years now. At first I collected anything and everything, but now I am quite choosy about what goes into my collection. I find that smaller paper items are what I love to add to my artwork—cancelled postage stamps collected in color families and subject matters such as butterflies, insects, circus, ticket stubs for events that sound interesting, raffle tickets in muted colors and great typography, themed items such as sewing that includes measuring tapes, thimbles, buttons and old zippers, game pieces of any size and shape as long as they are worn and show signs of being loved, etc.

Don't even get me started on books. Books are a great source of inspiration for me. I use an atlas for a worldly effect and the color palette goes perfectly with my muted aesthetic. Dictionaries of every shape and size fill my bookcase but add such an important element to my work. Field guides, poetry and music books are great to add interest. I have just started collecting books with schematics in them to bring my love of architecture and detail to life. These include mechanical drawings, electrical plans and charts of gauges, tables and chemistry numbers.

All this ephemera speaks to me personally and when I am including it in my art, it is saying something about who I am and what I love and conveys a message to the viewer. So, what do you want your art to say about you?

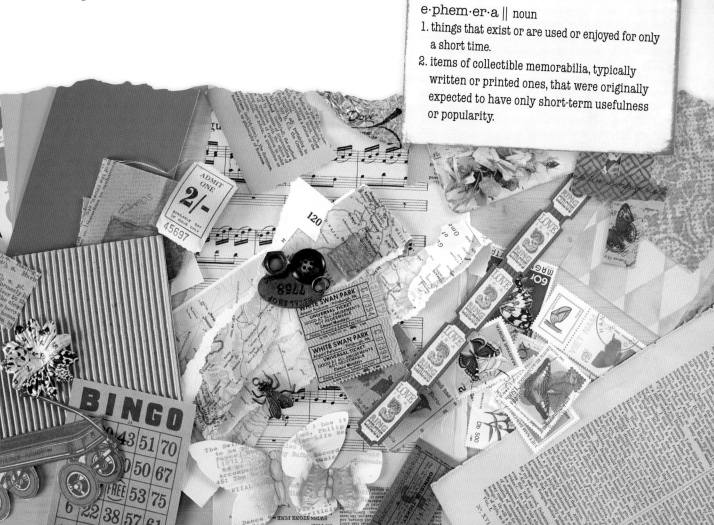

e·phem·er·a || noun
1. things that exist or are used or enjoyed for only a short time.
2. items of collectible memorabilia, typically written or printed ones, that were originally expected to have only short-term usefulness or popularity.

Nature's Treasures

na·ture || noun
1. the phenomena of the physical world collectively, including plants, animals, the landscape and other features and products of the earth, as opposed to humans or human creations.
2. the basic or inherent features of something, especially when seen as characteristic of it.

I live in the country and have a yard full of trees, flowers and endless inspiration. With each season comes a new set of treasures for me to choose from. I collect interesting leaves, especially if a small branch with acorns falls. I like to see how it all works together in perfect harmony. The leaves vary from tree to tree, making each one more interesting than the next. Bark, fruit, flowers and nuts also make the trees a continuous source of inspiration. Flowers offer seasons of budding, blooms and seedpods, an endless treat for my eyes. In the grass I find feathers of all shapes and sizes, wings of butterflies or dragonflies, and after a rain a sparkling spiderweb to intrigue my artist senses.

Nature's treasures are around you everywhere; you just have to open your eyes and see them. They are there waiting for you to discover them, I promise!

Endless Inspiration

Finding what speaks to you and keeps you inspired is so worthwhile to have at your fingertips. I have photographs, magazines and books within arm's reach in the studio. I just never know when I will want to find out the exact color of the swallowtail butterfly or what region it is from.

A trip to a local museum or art gallery will get your mind racing with ideas, techniques to try and great new color combinations. Let a composition surprise you and challenge you to recreate it. A local plant nursery, a walk outside or a trip to the zoo will offer unexpected sources of inspiration that you might find so intriguing you have to include it in your next piece of art.

Wherever you go, make sure to have a camera in hand. Taking your own photographs of what you find inspiring will help you become a better artist. Your photographs are taken the way you see and experience things, so they represent you already and are just waiting to be included in your artwork. How exciting is that? As you start to build up your photo library, make sure to organize it in a way that makes sense to you. Before long you will have thousands of photographs to go through.

Books. What can I say? I love them. I collect field guides because they let me correctly draw and learn about what I want to include in one step. I have guides about plants, birds, butterflies, insects, shells, marine life, rocks and the sky. They are an invaluable asset to have at my fingertips. I also have a bookcase just for the books I can repurpose, including old spelling and math books for children, dictionaries, flower and art books. Most of these were found at antique stores or bought at the local library sale, but the one thing they all have in common is that they spoke to me when I looked through them. All these are things I would include in my backgrounds or as added embellishments for my art.

As you can see, anything goes as long as you are choosing what you love. It is a quick way to include a secret part of yourself in your art. Believe me, it will be noticed and the viewer will get to know you just a little better.

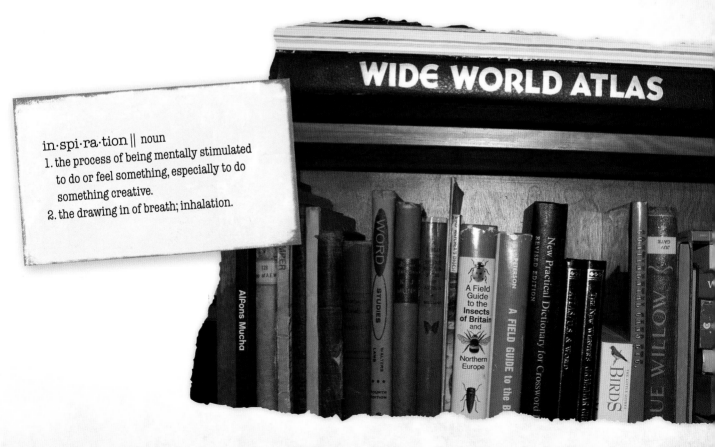

in·spi·ra·tion || noun
1. the process of being mentally stimulated to do or feel something, especially to do something creative.
2. the drawing in of breath; inhalation.

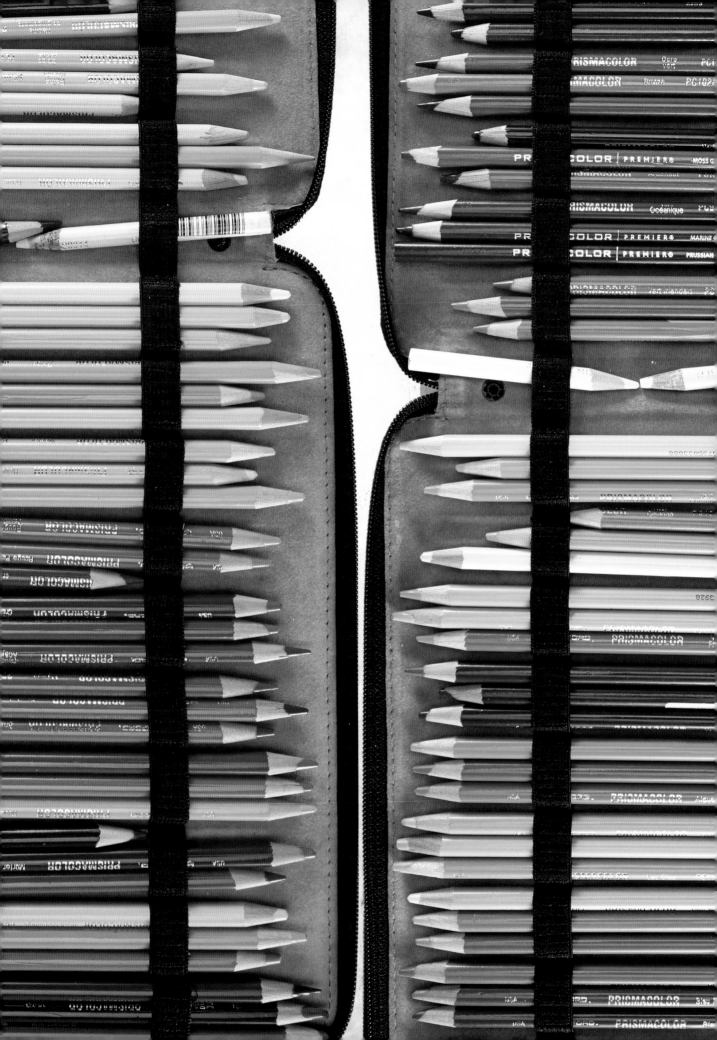

2 Colored Pencils

The use of colored pencils gives me the ease and freedom of capturing a realistic impression of almost anything. They are super easy to use because we are already used to holding a pencil in our hands. Plus, the technique I use to layer colors is simple to learn. Using colored pencils gives me the feeling of coloring with purpose, and for that I love this medium.

col·ored pen·cil || noun
1. a colored pencil, coloured pencil (see spelling differences) or pencil crayon is an art medium constructed of a narrow, pigmented core encased in a wooden cylindrical case. Unlike graphite and charcoal pencils, colored pencils' cores are wax-based and contain varying proportions of pigments, additives and binding agents.

Oil-based, water-soluble and mechanical colored pencils are also manufactured.

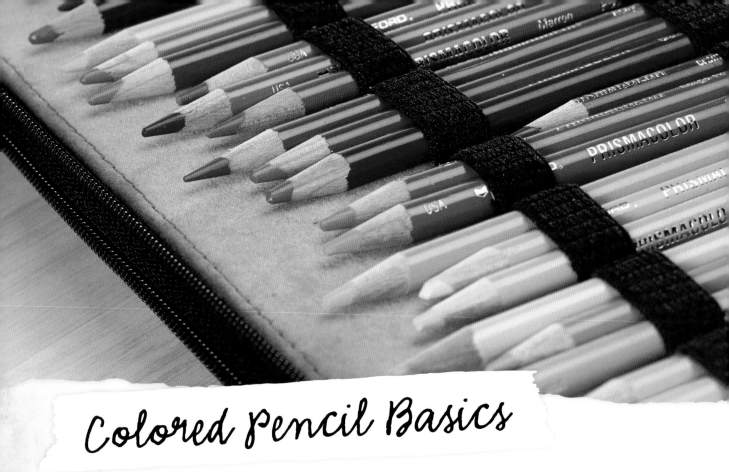

Colored Pencil Basics

There are a few things to know about colored pencils. First, you have to find a brand you like the feel of. Go into an art store and play with their selection of colored pencils in the store's demo area or buy a few of each brand to try at home. Believe me, you will know what you like almost immediately. I prefer Prismacolor because the lead is wax and very soft bodied for blending. For that reason, this is the brand I have used in this entire book.

Layering is important in my work. I use a light touch and a 30% pressure for all of my strokes. I can strengthen the color easily by applying another 30% pressure layer on top and can achieve the darkest value in about seven steps. This layering technique will let you accomplish about twelve layers before losing the texture of the paper, and that is an important consideration to me. There are many layering styles from coloring at full pressure to using a blending pencil, but I choose this method because it's how I taught myself to create values.

Next, is the stroke in which you render the work. I use circular and linear strokes. I prefer circular strokes because I don't have to think about direction or pressure as I fill in and include values. Circular strokes give me the freedom to just create without thinking too much, and I appreciate that.

For blending colors, I call this step "marrying." Hold out your hands, fingers pointing at each other. Now, with your fingers open, go into your other hand. Where your fingers come together is the

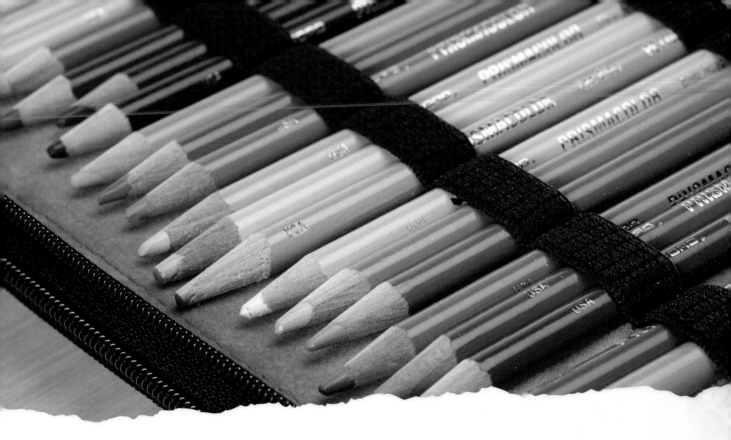

faded portion of the two colors. Where the palms are, the color is the strongest. So as these two colors come together, they "marry" one another to make a new color.

Line work is so important to my work because it cleans or crisps up an edge. It is a component in my designs that I do not ignore because it can add movement, elegance or make something seem flat and uninteresting in one stroke. Think of a paintbrush tip: You can press it flat and pull it up to a fine point all in one motion. You can use that same pressure with the pencil tip and create what I call "thick/thin"

pressure lines. You will love this technique and be surprised at the impact it will make on your work.

As with any new tool, the key to using colored pencils is practice. I suggest three colors and regular printer paper to start. They are inexpensive and you can create wonderful images with just these three pencils. The demos in this chapter will show you the importance of creating with gradual value changes no matter what stroke you choose.

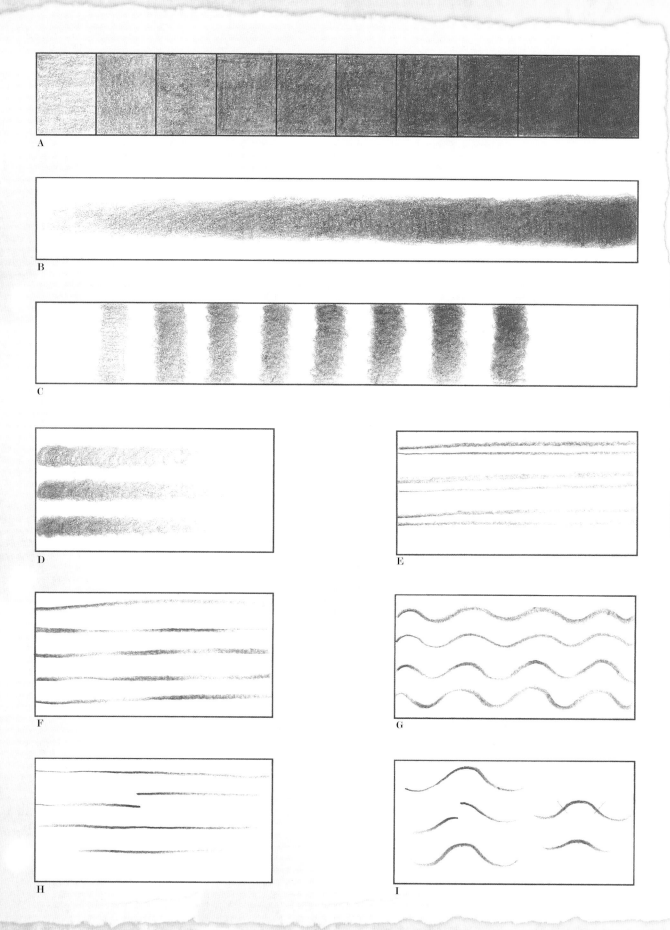

A

B

C

D

E

F

G

H

I

Coloring with Circular Strokes

I used Sienna Brown for this demonstration.

A

When using colored pencils, it is best to create a color chart so you can understand the range of each color. For this chart, I used a 10% (very light pressure) fill across the whole value scale using tiny circular strokes. Skipping the first square after each layer I added another 10% fill across the remaining value scale. I continued adding a 10% fill until they were all covered with values ranging from 1 to 10. This is the easiest way to build your layers without a lot of pressure and wax buildup.

B

For this chart I used just pressure, building layers from the lightest to the darkest value. Start at the dark end at about 30% pressure, then gradually fade away to nothing. Do it again, letting the fade happen faster with each layer. When you think you have achieved the darkest value possible at the right, you are finished.

C

I use 30% pressure or touch, for all of my rendering. I find it easy to control and the value range I get can gently build up with each layer. The first value, at the far left, is 20% and just a little too light. The next one, 30%, is correct. From there I added layers, letting them fade from the top gradually, achieving a nice blend. The last one at the far right is from seven 30% layers.

D

It takes a while to get a good gradation of value. Here I did each gradation in three steps to achieve a nice blend. You want to look for dark, medium and light value in the gradation. Notice in the second example there isn't much dark or light (it's mostly medium), so I corrected for the third example.

E

Line work is very important in my designing. The top two lines are a dull lead and sharp lead done at a continuous pressure. The second set of lines show dull/sharp with a medium value pressure. The third set of lines show value strokes created with more pressure at the left and less toward the right.

F

Creating values, or thick/thin lines as I refer to them, takes practice and control. The top example is pleasing in that it has all the values there—dark, medium and light. The second shows dark and light, no middles, so it creates a dashed line effect. The third shows medium and dark with just a little light. The fourth shows a very dark in the middle, making your eye focus right on it. The fifth shows medium, light and dark with no medium between the light and dark. The back half of this line is much better.

G

Curved lines can be used to show movement depending on how you make them, which should be taken into consideration as you determine your design composition. The first example was made with a dull point and the second, a sharp point. The third example shows more pressure at the tops of the hills, less at the bottoms of the hills. The fourth example shows it reversed. Notice how much more movement the bottom two have.

H

Here are the steps to create a thick/thin line like the top example. In the darkest section, pull heavy pressure to light pressure to the right. The next step is heavy pressure to light pressure to the left. If you put them on the same line, you would achieve the fourth example. Where the two lines start to meet there is usually a little ridge. Make a line over this middle area to smooth it out.

I

The line at the top left of this box is what we are going to create in multiple steps. The second mark (the one below the sample) is heavy pressure to light pressure toward the right. The third line is heavy pressure to light pressure toward the left. In the fourth I show them combined into one area. The mark at the top right side shows the area you will need to soften with the last step going over the middle.

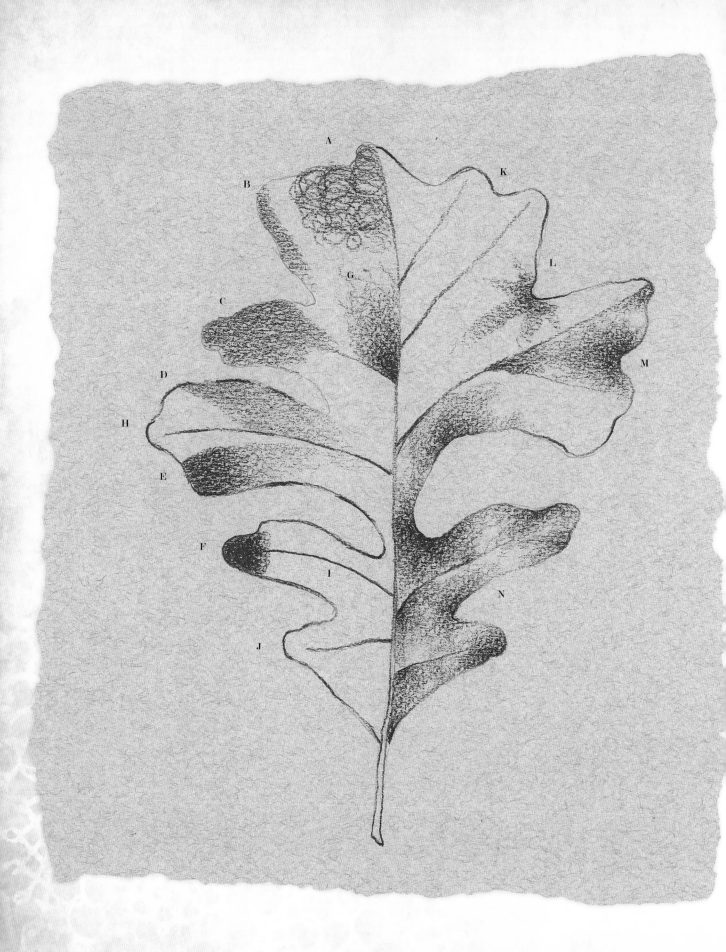

Sign up for our inspiring and free newsletter at CreateMixedMedia.com.

Circular Strokes
Oak Leaf Demonstration

I used Sepia colored pencil for this demonstration. This leaf has sections using both correct and incorrect circular strokes. Here's a list of what works and what doesn't.

A

Using circular motions that are too large creates empty space in the circle centers.

B

These are the correct size circles to use.

C

This section was done using all one value or fill (no layering).

D

The marks here go from light to lighter value.

E

This area uses dark to light value, but no medium value.

F

This section is too solid. No texture remaining in the paper means you pressed too hard.

G

This demonstrates a pleasing gradation of values.

H

These are thick/thin lines with no medium value, creating a dashed effect.

I

This line is too solid and doesn't add to the elegance of the design.

J

This shows great thick/thin lines and controlled pressure.

K

Start with thick/thin lines for the leaf outline and veins. The thicker areas will indicate where you put darker values.

L

This is how I start achieving my values. From the thick outline curve I pull dark values to light, letting them fade away. Notice how the lines create a starburst first that can then be filled in. You want to make sure you cover the whole area, not just the curve.

M

I like to work between vein lines to create the values. Here is a nicely blended section. Notice dark, medium and light values are present. You also don't see the outline in the darkest section.

N

This represents what the leaf should look like when it is finished. This section has nice gradation of values and some paper showing as the lightest values or highlight areas.

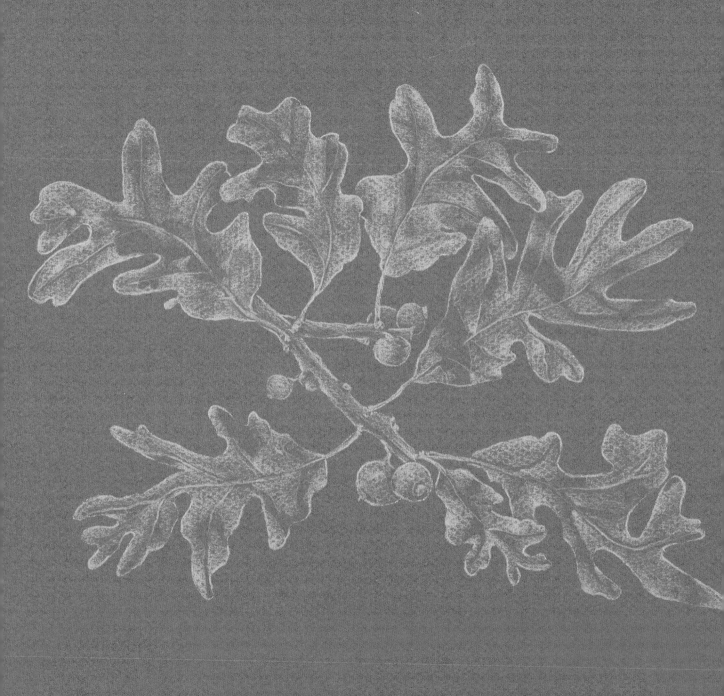

Circular Strokes
Fallen Treasure Project

This project is done with only one color but a lot of controlled values. Use the Circular Strokes Oak Leaf Demonstration as your guide to starting this.

Materials

Canson Mi-Teintes paper, Tobacco

kneaded eraser

Prismacolor pencil in Yellow Ochre

1 Draw your leaves on lightly with Yellow Ochre. You can also find a branch in your yard and trace around it to make it quicker. Lightly erase with a kneaded eraser anything you don't like or don't want included.

2 Once you are pleased with the design, work one leaf at a time. This will ensure you concentrate on value, not the whole design. Take your time.

Outline the shapes and add veins with thick/thin pressure lines. Begin filling in each little section with correct gradation values. Make some parts of the leaf brighter than others. If one leaf goes behind another, let more of the dark paper show to create a shadow or dark value.

3 For the acorns, make sure you don't get too heavy with the bright layer. You want to still see the paper texture. If you are too heavy-handed, you will create a hot spot or bright spot of color, and that area will demand the viewer's attention. If this happens, use your kneaded eraser. Flatten it out, lay it over the area and press firmly. Lift the eraser to remove several layers of pencil. Fix the acorn with lighter layers.

4 When you are all finished, evaluate the piece as a whole and make sure one section is not commanding all of your attention. If it is, it probably has more bright or dark sections than the rest of the piece. Adjust the values as you see fit.

Coloring with Linear Strokes

I used Kelp Green for this exercise.

A

When using colored pencils, it is best to create a color chart so you can understand the range of each color. For this chart, I used 10% pressure to fill the whole value scale using horizontal lines. For the next layer, I skipped the first square then did another 10% fill across the value scale. I continued adding a 10% fill until they were all covered with values ranging from 1 to 10. This is the easiest way to build your layers without a lot of pressure and wax buildup.

B

For this chart I used vertical lines (I turned the paper to the side), building layers from the darkest to the lightest value. Start at the dark end at about 30% pressure, then gradually fade away to nothing. Do it again, letting the fade happen faster with each layer. When you think you have achieved the darkest value possible at the right, you are finished.

C

The first value is 30% pressure using horizontal lines for the strokes. From there I added layers, letting them fade from the top, gradually achieving a nice blend. The last one is six 30% layers.

D

Just as with circular strokes, it takes a while to get a good gradation of value using linear strokes. You want to look for dark, medium and light values. The top line is too light and the second line is too even. The third line has a pleasing gradation from dark to light.

E

To create a gradated value in the middle of an area, start by filling the area with 30% pressure lines. Determine where you want your darkest value and add several layers of 30% values, letting them fade to the right as in the second example. Repeat the layers, letting them fade to the left. When you do both, you will have the results of the third example.

F

Line work is very important in my designing. The top set of lines is going to be filled with values, so I drew them using the thick/thin pressure. The dark areas in the lines mark where the darkest values will be added. The second set shows the initial layer of vertical lines. Start with 30% pressure and fade to the right. Keep adding values until the darkest point matches the line work at the top and bottom. Repeat the layering on the left side until the layers are the same value in the darkest area as the third example.

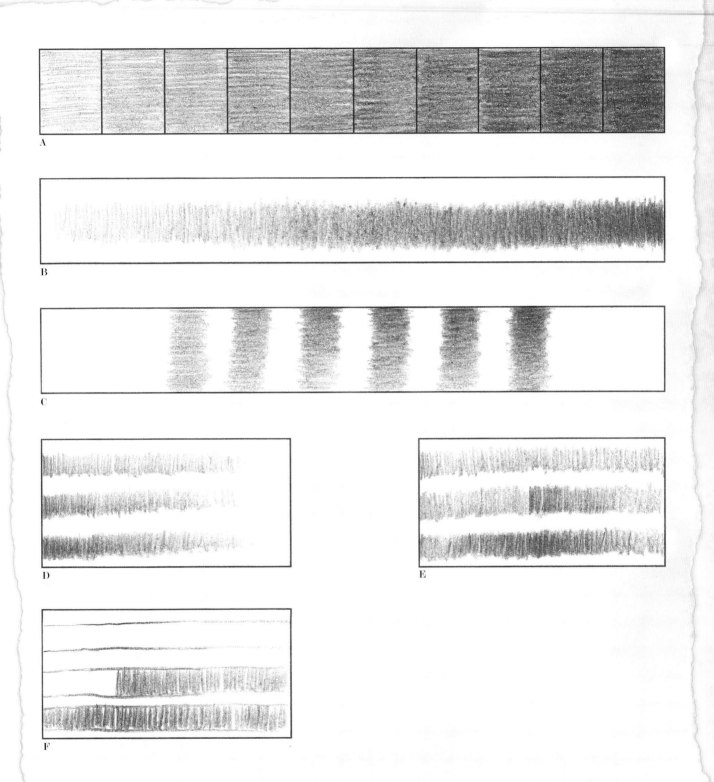

A

B

C

D

E

F

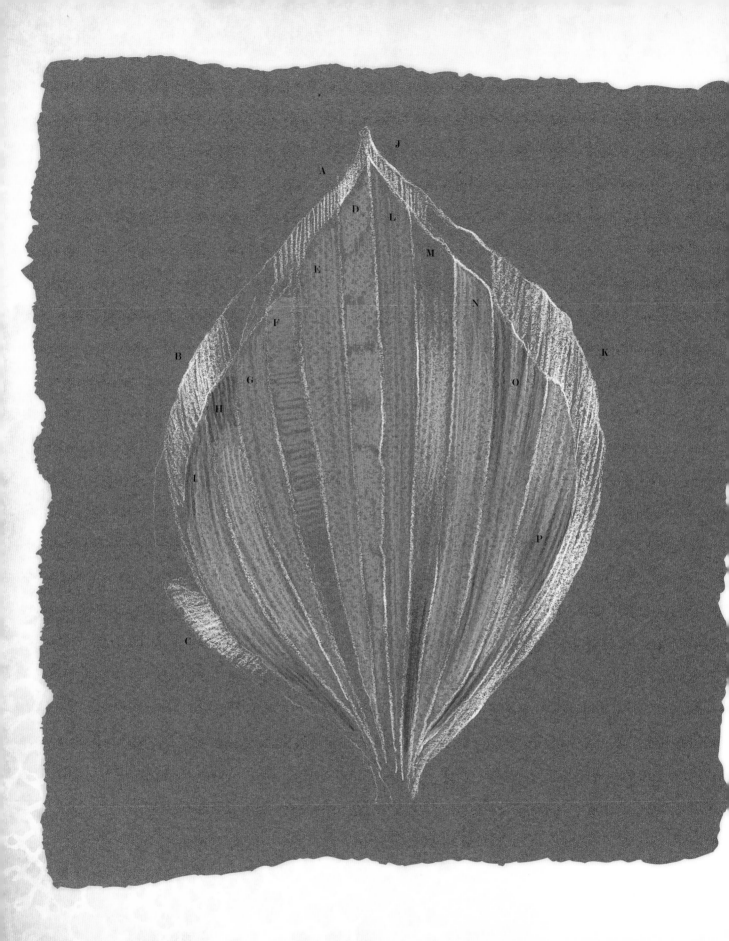

Sign up for our inspiring and free newsletter at CreateMixedMedia.com.

Linear Strokes
Hosta Leaf Demonstration

The hosta leaf to the left uses linear strokes correctly and incorrectly as explained below. I used Cream, Dark Green, Limepeel and Yellow Chartreuse for this demonstration.

A

The sharpness of the pencil point has to be consistent when working with linear strokes. If you start with a sharp point, you have to end with a sharp point. This section of Cream shows sharp point lines to the left and, to the right, values with a dull point. See how much paper is still showing in the sharp point area?

B

When drawing thick/thin outlines, making the linear values inside the outline match the values of the outline is important to any design. You never want to see the outline first.

C

It is important to follow the growth direction of natural objects when using linear lines. In this section, the lines are going against the growth direction, changing its appearance. Compare this side to the right side of the leaf. One creates and enhances the shape, the other negates it.

D

Using short vertical strokes is easy to do but note that it creates a pattern that may be unwanted in some designs.

E

Long, smooth vertical lines create the correct movement within the hosta leaf shape.

F

Gradated horizontal lines create an unnatural growth direction in the leaf.

G

Correct vertical lines fill the leaf segment.

H

Adding dark and light strokes helps create values, but these are too harsh. Notice that the strokes do not change pressure, creating a stop-and-start line for each color.

I

These are correctly blended linear strokes. Compare them to section H. The dark and light added values are gradated to blend naturally into the fill.

J

Start the drawing with thick/thin pressure lines to the light border and veining.

K

Add more values to create highlight, taking the growth direction into consideration.

L

Fill the interior with long vertical strokes of Limepeel.

M

Use Yellow Chartreuse as the highlight color with the main values. Be sure to fade the strokes at the edges. With Dark Green, apply the dark lines, letting them fade into the middle of the leaf for shadows.

N

This section shows the Limepeel fill with Yellow Chartreuse highlights, nice and blended.

O

This section shows the Dark Green shadows added.

P

This section shows both N and O with the addition of Cream to brighten.

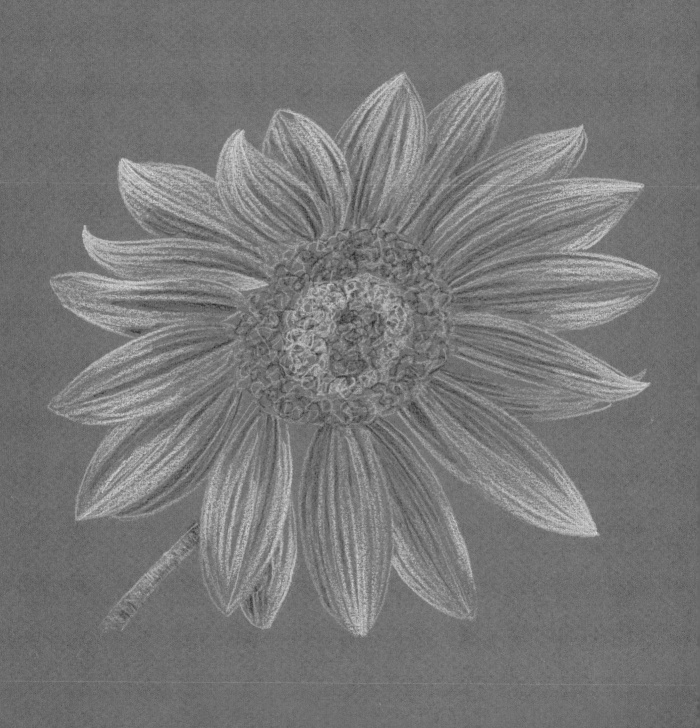

Linear Strokes Sunflower Project

This project is done with three colors and a lot of controlled values. Use the Linear Strokes Hosta Leaf Demonstration as your guide for how to start this drawing.

Materials

Canson Mi-Teintes paper, Twilight

kneaded eraser

Prismacolor pencils: Cream, Imperial Violet, Jasmine

1 Draw your sunflower petals on lightly with Jasmine. I included a small stem to the left to give it movement and context. Lightly erase with a kneaded eraser anything you don't like or don't want included.

2 Once you are pleased with the design, work one petal at a time. This will ensure you concentrate on value, not the whole design. Take your time. Notice the outer edges are glowing and there are more light values to the left side than the right.

Using Jasmine, outline the petal with thick/thin pressure. Begin filling in each petal with 30% pressure linear strokes that lead into the center. Make sure to gently curve the stroke to match the shape of the petal. Once the petal is filled, make parts of the petal brighter than others by going over an area again with a fading stroke. If you want the tip to be brighter, start there and fade into the center. If it goes behind another petal, let more of the paper show to create a shadow or dark value.

3 Brighten the petal with Cream to establish the light areas. Keep the linear strokes random and not the same length or pressure. This will add interest to the finished piece.

4 The shades are put in with Imperial Violet from the center out, so there is more pressure at the center area and it fades into the tip of the petal.

5 The center is done with squiggly strokes to give the idea of being filled with sunflower seeds. Do all three sections with Jasmine first, then brighten the second circle with Cream. Go over the whole center, one section at a time, with Imperial Violet to darken.

6 The stem uses all three colors and the strokes are done horizontally with a slight curve instead of vertically to create the roundness of the stem.

7 When you are all finished, evaluate the drawing as a whole and make sure one section is not gaining all of your attention. If it is, it probably has more bright or dark sections, so adjust as you see fit.

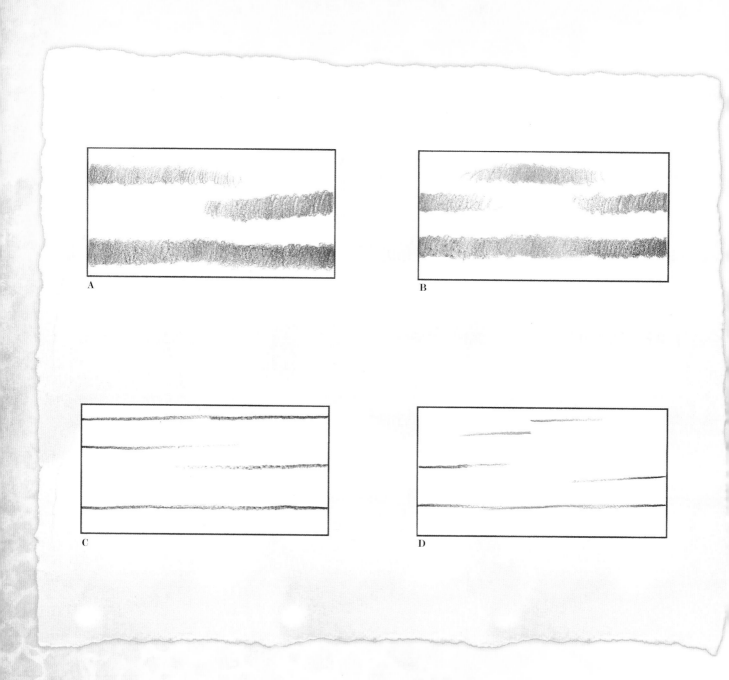

Blending or Marrying Colors

I used Chocolate, Kelp Green and Mineral Orange for this exercise.

A

To blend or marry colors, I begin by taking one color, Kelp Green in this case, and create a gradation beginning with 30% pressure from dark to light (top line). With the second color, Chocolate, I created a gradation from light to dark, second line. The third line shows the colors on the same line with the light faded values blending together to create the new color.

B

To blend three colors together seamlessly, create the middle color first using Mineral Orange with the darkest value in the middle and both ends fading away to nothing. For the end colors, do the same steps as in A (shown on the second line). The third line shows the nice gradation of all three. If an area looks light in value, I will add color to the faded areas to even it out. This will strengthen the color line and blend a bit better.

C

Creating values, or thick/thin lines as I refer to them, takes practice and control. Blending two colors together to create a unified line takes patience and practice. The top example shows the two colors meeting one another, creating a break or harsh line where they meet. The second line shows Kelp Green in a valued line of dark to light. The third line shows Chocolate in a valued line of light to dark. The fourth line shows them on the same line with the middle section perfectly blended together, creating a new color where they meet.

D

To do a line of three colors you must create the middle value first. The top line is Mineral Orange created from dark to light, left to right. The second line is Mineral Orange done dark to light toward the left. The third shows Kelp Green dark to light. The fourth shows Chocolate light to dark. The bottom shows them all on the same line blending together and looking unified. If the lines look uneven where they meet at the light values, you may have to strengthen them with added color.

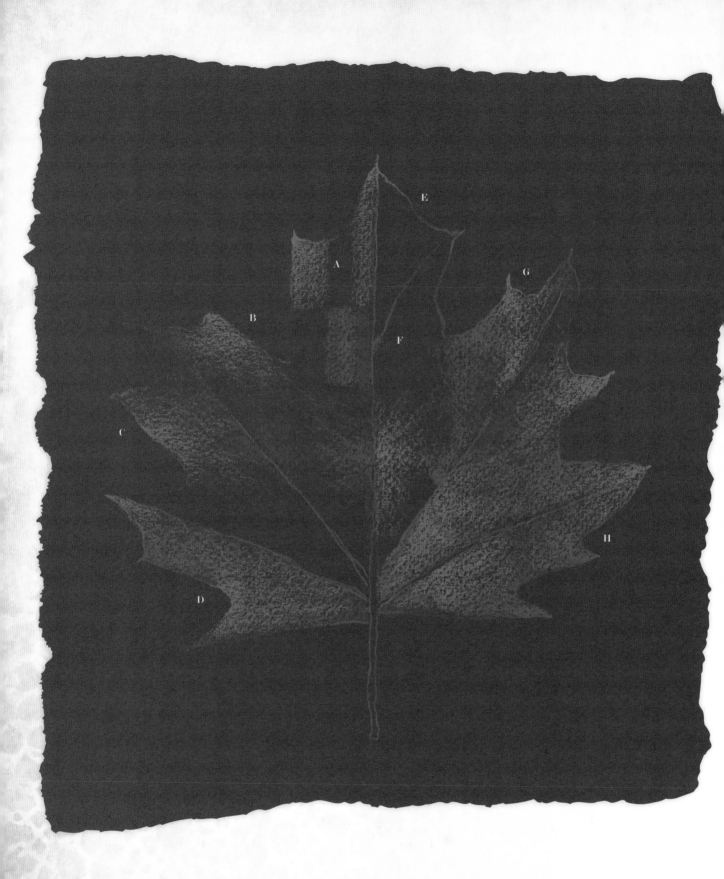

Sign up for our inspiring and free newsletter at CreateMixedMedia.com.

Blending, or Marrying, Colors
Maple Leaf Demonstration

This maple leaf demonstration shows correct and incorrect ways to blend, or marry, two or more colors. I used Goldenrod, Limepeel and Yellow Ochre for this demonstration.

A

Here the shapes are too defined and would cause hard edges when blending with another color.

B

Here the marks make correctly gradated values but not enough of the light value color for overlapping. This results in too much of the paper color showing.

C

The colors are nicely overlapped but there's very light color in the middle where they create a new color.

D

This demonstrates correct overlapping. I strengthened the middle values by going over the area with the lightest color again.

E

Start the drawing with thick/thin pressure lines of various colors in the outline and veining. You can create them first with a 30% pressure and darken as you go, but I prefer to do it in one step.

F

Begin the process of color gradations spreading out in all directions to intersect other colors.

G

Start blending one color into the next, making sure the overlapping areas remain consistent and the paper color fades into the background. This is still light in the blending stage.

H

Apply more medium values (note the lack of paper color here compared to G) to smooth and join the color blending. This is the coverage I look for when blending.

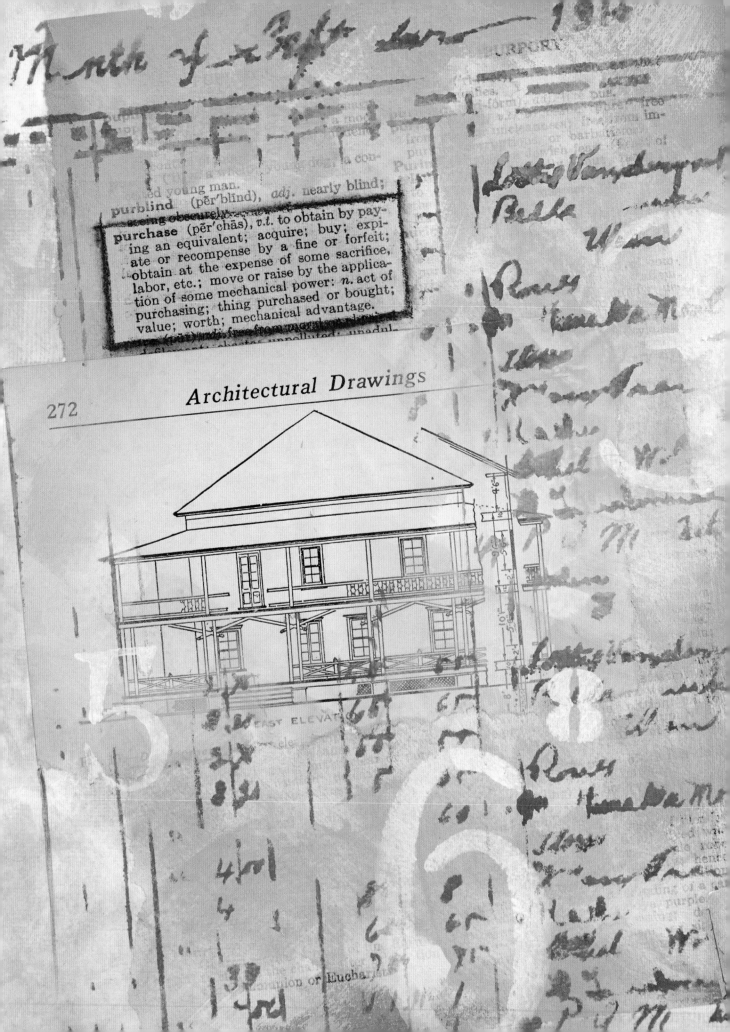

purblind (pĕr'blīnd), *adj.* nearly blind; seeing obscurely.

purchase (pĕr'chās), *v.t.* to obtain by paying an equivalent; acquire; buy; expiate or recompense by a fine or forfeit; obtain at the expense of some sacrifice, labor, etc.; move or raise by the application of some mechanical power: *n.* act of purchasing; thing purchased or bought; value; worth; mechanical advantage.

Architectural Drawings

272

EAST ELEVATION

3 Design

Design is so important to an artist. Learning to train your eye to what you like is part of the challenge when you are first starting out, but over time you will come to understand what your design aesthetic is. Being able to see in your mind's eye what you want to create and how you want to represent it in your art is an endless journey.

de·sign || verb
1. to conceive and plan out in the mind.
2. to intend.
3. to devise for a specific function or end.
4. to make a pattern or sketch of.
5. to conceive and draw the plans for.

de·sign || noun
1. a particular purpose; deliberate planning.
2. a mental project or scheme; plan.
3. a secret project or scheme; plot.
4. aggressive or evil intent.
5. a preliminary sketch or plan.
6. an underlying scheme that governs functioning, developing or unfolding; motif.
7. the arrangement of elements or details in a product or a work of art.
8. a decorative pattern.
9. the art of executing designs.

Your Design Style

Let me ask you some important questions to see if you know your design style better than you think. Write down the first thing that comes to your mind.

1. Are you linear or circular?
2. Do you prefer white space or filled space?
3. Do you like colors or neutrals?
4. Do you prefer soft or hard edges?
5. Do you like things to match or are you unconventional in putting things together?
6. Patterns or plain?
7. Decorative or functional?

As you can see, this will help you narrow things down as you create your design. By answering these seven questions, you can tell a lot about yourself, and that is a great place to start.

I am an architectural renderer who is inspired by nature but uses a muted palette for the most part. With this being said, I love straight lines and circles drive me crazy. I like white space; filled spaces make me nervous. Neutral and muted shades work best for me, but I do like an occasional pop of color, just not an intense one. I like a mix of hard and soft edges because it adds interest for the viewer. I put things together in unconventional ways because I love texture and mixing old with new. Most of the time I gravitate toward plain designs but love background patterns if they are soft and undistracting. Whether the art is decorative or functional doesn't matter to me; I just want to create.

> "Design is not making beauty, beauty emerges from selection, affinities, integration, love."
> —Louis Kahn—

When you look through this book, you will see my style and design aesthetic right away. For me it is all about the details. I like my finished pieces to look one way from across the room, but as you come closer, you'll see all the details I have included.

Design is something you can learn, but it can also be something you just have. Trust your gut or your instincts and they will usually lead you down the right path. Our designs have personal consequences because they reflect who we are, what we like and what we want to share with the world. Can it really get more personal than that? I don't think so. You do matter and have a unique design aesthetic that is personal to you and you only!

Sign up for our inspiring and free newsletter at CreateMixedMedia.com.

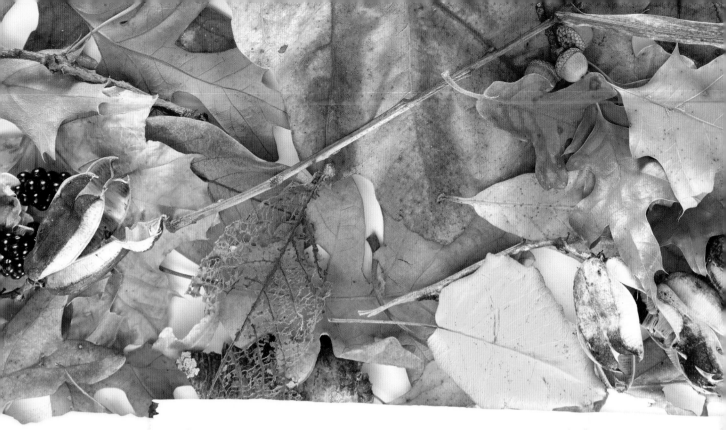

Components of Artwork

The three components of artwork are subject, form and content. The **subject** is the object of the piece. **Form** is the visual organization within the artwork. **Content** creates the impact or meaning of the art.

Good design takes a while but once you find a formula that works for you, use it for a while until it comes naturally. Work in a size that you find comfortable. I prefer working no larger than 11" × 14" (28cm × 36cm). That doesn't mean from time to time I won't go larger; it just means I find it easier to design around this size and all of my collected ephemera works well within it.

Divide your substrate into thirds horizontally and vertically. Try to avoid placing the focal point in the center of your art. It's better to place the focal point at intersecting points in the grid. It is also a great challenge to do a high and low composition using the bottom or top third of the lines to encompass your center of interest. Lead the viewer's eye around your artwork. This is so important because you want the viewer to engage with and experience what you created.

You will see in the demonstrations within this chapter how a simple turn of a butterfly can keep your attention within the art. Using what you learn about design, look at the work of other artists and try to figure out what principles and elements of design they are using. This is a great way to become familiar with the principles and elements of design, and you might discover a unique way to challenge yourself with new and experimental arrangements.

Elements of Design

The six elements of design are line, shape or form, texture, color, value and space or perspective.

Line is the path your eye takes to get to a specific point.

Shape is created when a line intersects or crosses itself.

Texture is the actual or created tactile quality of the mediums used in the art.

Color comes from light and can be described by hue, value and intensity.

Value is indicated by the light and dark areas in the work.

Space is the area that a shape occupies within the work.

Principles of Design

The five principles of design are balance, rhythm, unity, proportion and emphasis.

Balance describes whether the art is symmetrical (the same on both sides) or asymmetrical (different on each side).

Rhythm describes the movement of your eye around the art.

Unity is created when things looks correct together and create harmony.

Proportion is the comparison of sizes and shapes of the objects in the art.

Emphasis is the focal point or center of interest.

Exploring a Low Horizon Composition

I wanted to use two strong elements, the "4" scrapbook die cut and the orange paint chip, in this collage because they are similar in size. I pulled other elements to create the design using the colors in the 4. Even though the colors in the various pieces go together so well, they seem disconnected from each other given the fact that they share such a tight space in this arrangement. The stamps arranged on top of one another create a very similar shape and size as the 4, so you don't know which one is supposed to get your attention first.

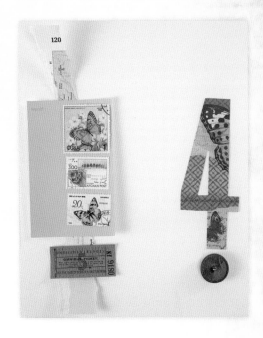

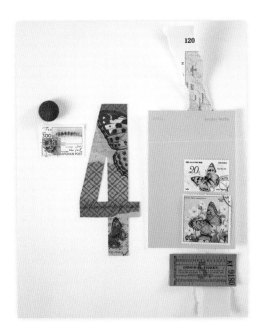

Here I moved the 4 to the center of the space. It now commands your attention because of its color, size and placement within the space. Notice you really stay in the middle third of this composition instead of moving throughout it, making the arrangement feel very stagnant.

I moved everything down to create a low horizon composition. It is called that because it uses the bottom third of the space. By moving around the stamp and ticket colors, and making the button stand on its own, the 4 is grounded to the bottom of the space. The tall skinny map and white butterfly allow your eye to move upward to all the open white space at top left, relieving the cluttered area of the bottom elements. Can you feel yourself take a breath when you get to that open space?

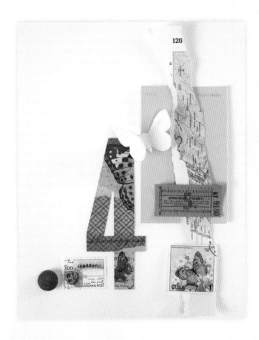

An Adventure in Texture

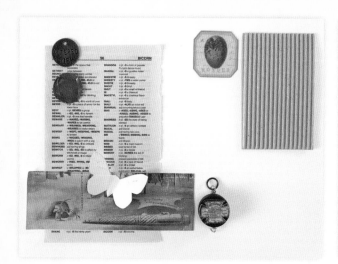

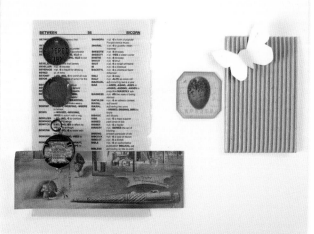

I wanted to focus on texture so everything has a definite feeling or pattern to it, yet the lack of color makes it all go together very well. I like the left side but feel the disconnected elements at the top right don't enhance the design. Cover them with your hand and see how much better the space feels.

I wanted to stack the round elements to create a rectangular shape almost the same size as the scrapbook paper at the bottom. I like the way the left side elements fit together. The texture and butterfly are nice complements to the design and add a bit of air to the right side. However, the egg shape is too close to the size of the round elements, so it is distracting my eye from the focal point.

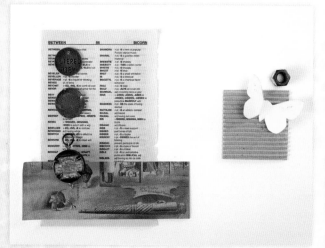

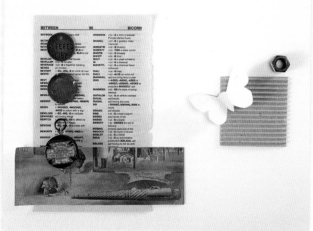

Making the textural element in the space on the right more square adds a nice new shape. The nut adds a new circle but one much smaller, so it really doesn't demand your attention. I want you to follow your eye around this design. Start at the row of round objects, across the scrapbook paper and right out of the space. This is because the butterfly is so white and heading to the right.

Here, the only change is the placement and direction of the butterfly. Angling it back to the other elements now leads you back to the dictionary page and the line of round elements, creating a better design composition.

Sign up for our inspiring and free newsletter at CreateMixedMedia.com.

Exploring Color Balance

Even though this arrangement uses a continual color, the space feels very top heavy. The paint swatch is disconnected to everything because nothing overlaps it. I like the addition of the round button, but right now that is where my eye goes because it has so much white space around it, showcasing the dark value of it.

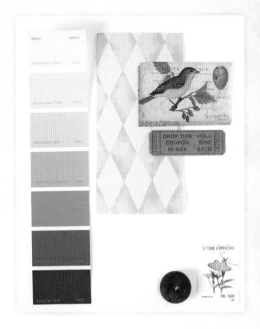

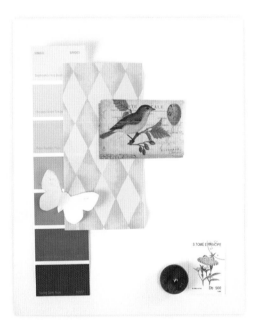

I like the paint swatch being connected to the other elements; the connection helps it blend in now and not stand alone. Because of the overlap, it creates a nice long grouping. The addition of the white butterfly breaks up the vertical shape and continual color block. I still feel the button gets too much of my attention because of its placement. I also miss the dark color of the ticket in the design space.

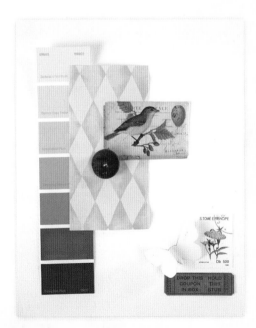

This arrangement feels really balanced and now the button brings your attention up to the bird card, which is my intended center of interest. The bottom grouping complements the design and, with the addition of the ticket, there is weight to this element grouping as well. The butterfly pointing at the bird reinforces the card's importance within the space.

Layering and Movement

I wanted to make you feel boxed in without room to get out of the design. See how nothing leads you outside the boxed area? Had I changed the angle of the butterfly, you could have been led out of the box. Notice that you also don't know where to focus your attention. That's because everything is similar in shape and color and almost every piece overlaps with another, not giving you any break within the space.

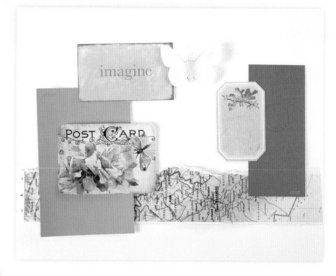

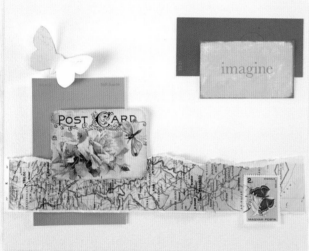

Breaking away the elements at the top right gives you a little room to breathe, but not much. This arrangement starts to create a focal point with the postcard element and gives movement near it with the white butterfly.

By creating layering of the dark and medium colors plus a pattern around the postcard, you can see how it now commands your attention. For movement, start at the postcard and your eye will travel down the map and up to the colorful stamp. The butterfly is facing in the direction to keep your eye inside the space. Its placement allows you to capture the edge of the paint swatch to move your eye around the design once again.

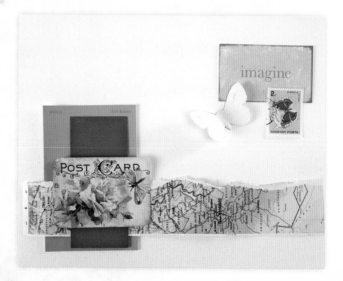

Design That Works

Letting yourself imagine and create design compositions is a great way to have fun and just relax. Here are a couple collages that work because of the open spaces, varied sizes and shapes of the elements, textures for the senses, visual stimulation of line and wonderfully muted color palettes. They each convey a feeling and mood yet can be appreciated standing on their own. Add them to a piece of art and a conversation is sure to break out.

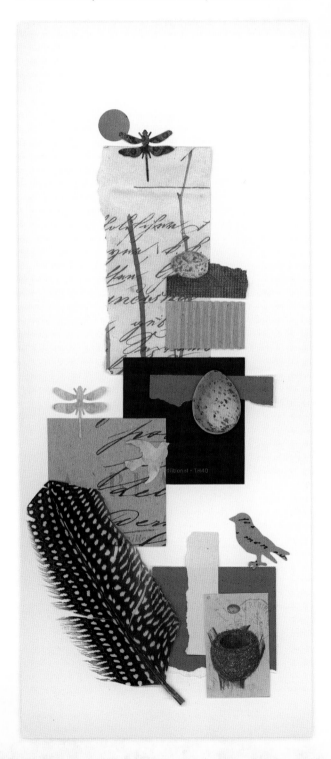

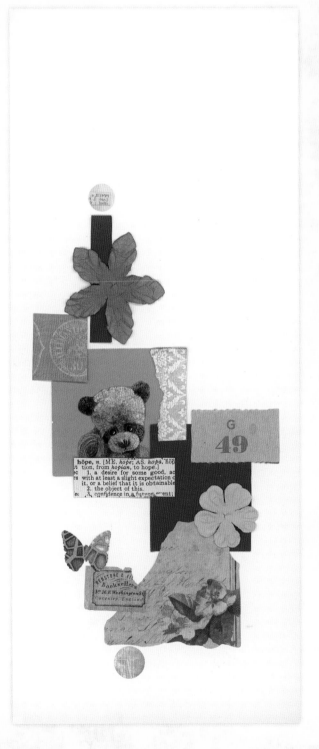

Visit CreateMixedMedia.com/colored-pencil-collage for bonus materials.

WARATAH 30c

AUSTRALIA
N WILSON

4c

U.S. POSTAGE

THIS SIDE OF CARD IS FOR ADDRESS

5.50F

BELGIQUE-BELGIË

Crucifix toad

AUSTRALIA 70

30

squish

4 Textures and Tools

tex·ture || noun
1. the feel, appearance, or consistency of a surface or a substance.
"skin texture and tone"
synonyms: feel, touch; appearance, finish, surface, grain; quality, consistency; weave, nap
"the texture of the burlap is coarse and nubby"

|| verb
1. to give (a surface, especially of a fabric or wall covering) a rough or raised texture.
"wallcoverings that create a textured finish"

tool || noun
1. a device or implement, especially one held in the hand, used to carry out a particular function.
"gardening tools"
synonyms: implement, utensil, instrument, device, apparatus, gadget, appliance, machine, contrivance, contraption; informal: gizmo
2. a distinct design in the tooling of a book.

|| verb
1. to impress a design on (leather, especially a leather book cover).
"volumes bound in green leather and tooled in gold"
2. to equip or be equipped with tools for industrial production.
"the factory must be tooled to produce the models"

I love, love, love texture and what it represents to my artwork—interest. After the subject, it is the first thing I think about when creating. For me it sets the mood and gives the piece an emotion and depth that is fun to watch unfold as I create. It is one of my favorite design elements and the one that challenges my artistic muse the most.

Texture is found everywhere and many times I will walk through the garden or woods and stop in my tracks. A piece of bark, a long weed, a layer of leaves on the dirt path—all these items will have me wondering how to recreate them in my art. The simplistic way nature groups things to give them depth and dimension takes a while to mimic, but when you know some quick and easy steps, you will be on the path to endless possibilities.

In this chapter we will discuss simple textures done with items found around your house. Some of my favorites are water, table salt, bubble wrap, paper towels and sponges. We will also incorporate tools to give your pieces a little more interest and creativity. They will include working with gesso, stencils, rubber stamps, doilies, fibers and a few very fun hardware store finds. This journey into textures is only the beginning, but I know you will continue to discover more on your own once you start looking in the right direction.

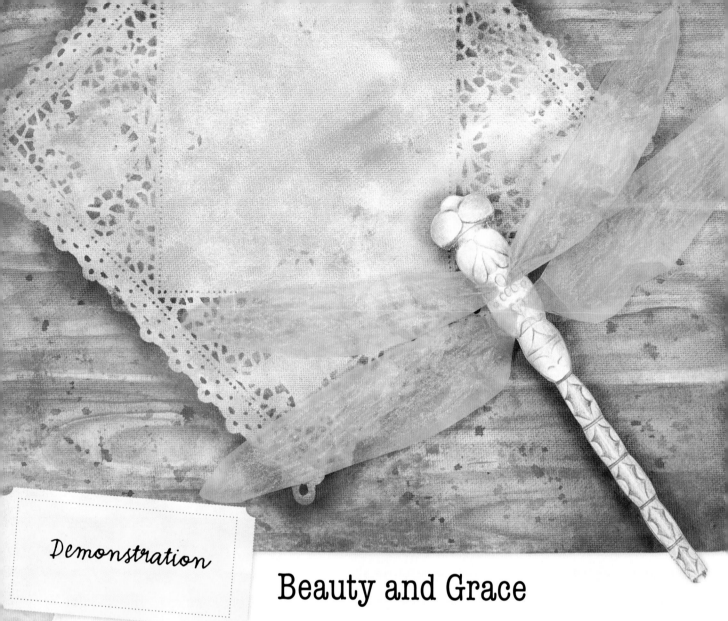

Beauty and Grace

The paper doily. It comes in so many shapes and sizes and adds such a charming element to your artwork without a lot of work. Perfection in a little piece of paper heaven. Combined with the beauty of the green darner dragonfly on a wooden table, it is a graceful combination sure to please all of your senses.

Materials

9" × 12" (23cm × 30cm) canvas panel

bristol board and cardboard scraps

brushes: 1-inch (15mm) wash, no. 10 round, ½-inch (13mm) DM stippler

clear glue

container of water

DecoArt acrylic paints in Dark Chocolate, Fawn, Sable Brown

dragonfly template drawing

Krylon Workable Fixatif

painter's tape (optional)

palette

paper doily

paper towel

pencil or black transfer paper

Prismacolor Colored Pencils in Cloud Blue, Dark Brown, French Grey 70%, Limepeel, Muted Turquoise, Pale Sage, White

ruler

scissors

sewing pattern paper or tissue paper

table salt

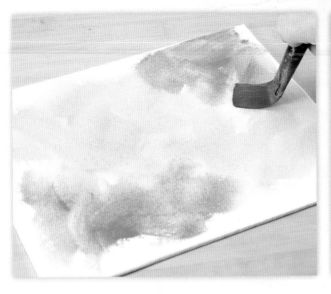

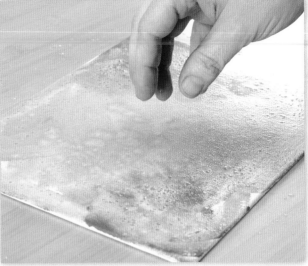

1 Paint the Background Colors

Dampen the canvas panel with water. Loosely add paint with X brushstrokes, first using Fawn in the area where the doily will go, then using Sable Brown in the corners. Blend the colors where they meet.

2 Add Table Salt for Texture

While the paint is still wet, sprinkle the panel with table salt, avoiding the area where the doily will be. Dip your fingers into water and splash drops across the canvas.

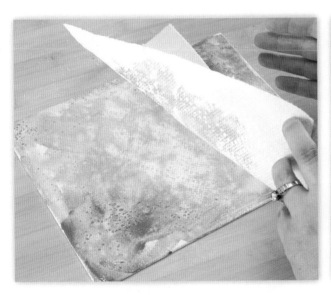

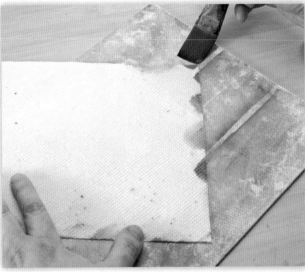

3 Press on Paper Towel for Texture

Wait a couple of seconds for the paint to start drying, then gently press a paper towel down onto the surface and lift. You are removing the splashes, not the color, so use a light touch. Allow the panel to dry then wipe off the salt.

4 Begin to Paint the Wood Grain

Cut a paper towel down to the size and shape of the doily you will be using. Position the paper towel on the canvas panel where the doily will be to protect that area. With a wash brush and Sable Brown, start creating the wooden boards for the table. Stay off the paper toweling—you don't want the imitated wood grain there. To create the wood planks, pull the brown paint in one direction with a 1-inch (25mm) wash brush. Turn the brush to the side and pull the paint in the opposite direction to get the plank division lines.

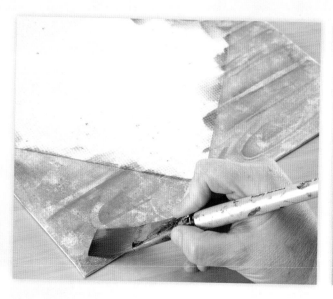

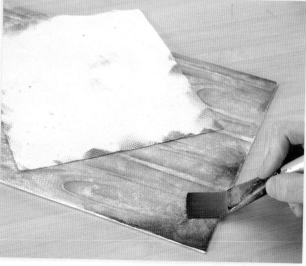

5 Add Darker Shades in the Wood Grain

Add more wood grain lines with Sable Brown. Shade the outer edges of the panel with Sable Brown. Pull the paint in U shapes to create the rings of the wood grain, and then back and forth to create the wider rings. Allow the paint to dry or speed it up with a heat gun or hair dryer.

6 Deepen Shading at the Corners and Edges

Shade the edges of the panel, especially the lower right, with Dark Chocolate. Your dragonfly will be going in this area, so the shading will help define its shape.

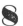

7 Spatter Paint on the Wood Grain

Dip your no. 10 round brush into water and mix watery puddles of Sable Brown and Dark Chocolate. Load the brush, then gently tap it against another brush handle to release spatters around the canvas panel. Allow the paint to dry thoroughly.

8 Remove the Paper Towel

Remove the paper towel and make sure you have nice values throughout the piece.

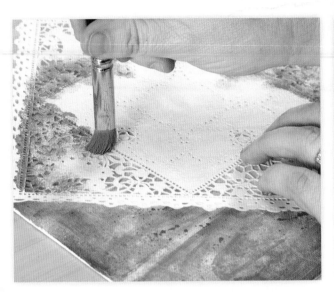

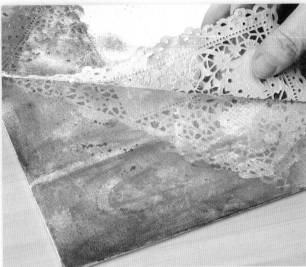

This is what the paint will look like with just one color added.

9 Begin Stenciling Through the Doily

Place the doily on the panel where the paper towel was and hold it in place. You can place a couple pieces of painter's tape underneath to keep the doily from moving. Dampen the DM stippler brush with water, then blot it dry. Load the brush with Sable Brown, then pounce it onto the palette to remove excess paint. Begin pouncing in an up-and-down motion around the center and to the edges. Do not do the edges yet.

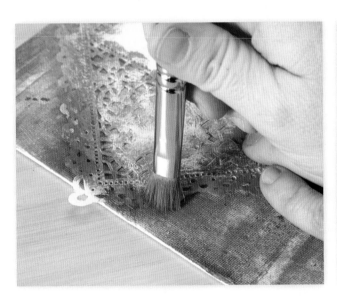

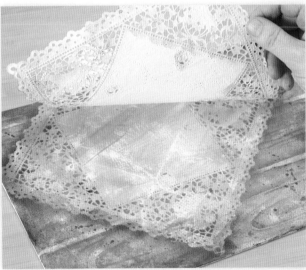

10 Stencil Around the Outside of the Doily

When you get to the edges, rinse the brush, blot it and load only half of the brush with Sable Brown. With the paint side of the brush toward the doily and the water side out to the canvas, begin pouncing along the doily edge moving out about ½" (1cm) away. You should get a hard line around the doily and it softens as it moves away from the edge.

11 Deepen the Shades of the Stenciling

Determine where your darker values of wood grain texture just outside the doily are and deepen them by pouncing with Dark Chocolate here and there. Load the brush the same way you did for the edges to give you a softer side to help blend within the inner doily areas. Skipping around the doily will create more movement and a great, believable doily edge.

Remove the paper doily to show the painted outline.

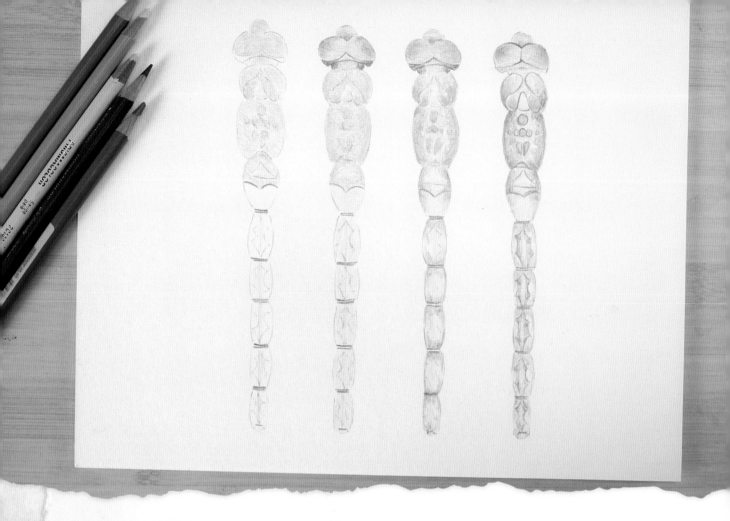

12 Draw the Dragonfly

Transfer the dragonfly template drawing to bristol board scrap with pencil or black transfer paper. The dragonfly will be done using colored pencils in circular strokes. Note that the dragonfly is divided into three main sections: the head, the body and the tail.

13 Color the Head

Color the nose highlight White, then go over that area and fill the nose with Pale Sage. Shade the nose with Limepeel.

Highlight the eyes with White and create a dark center, softening out toward the edges. Go over the White and fill the rest of the eyes with Pale Sage, shading with Limepeel.

Highlight the neck using Cloud Blue and add shading with French Grey 70%. Add Cloud Blue over the front of the eyes plus tiny French Grey 70% strokes.

14 Color the Body

The body should get White highlights, brighter in the center then fading to the outer edges. Go over all the body and fill with Pale Sage. Shade the body using Pale Sage and deepen with Limepeel. Brighten the White if needed.

The main spots on the body are White with Pale Sage over them. Shade the spots with Limepeel and outline them with French Grey 70%.

Fill the top part of the lower body section with Pale Sage, then shade more Pale Sage followed by Limepeel. Deepen the lower body with touches of French Grey 70%. If it becomes too dark, add Limepeel over it. The bottom half of the lower body section should be filled with Cloud Blue, shaded with Muted Turquoise and deepened with a touch of French Grey 70%.

15 Color the Tail

Draw a Cloud Blue line down the entire tail center with a ruler. To divide each segment of the tail, add a horizontal double line with a sharp French Grey 70%. Fill each segment with Cloud Blue. Shade the edges of each segment with Muted Turquoise. Outline a diamond shape in each segment with French Grey 70%. Shade inside the diamond with French Grey 70% values. On the outer edge corners of each segment, shade lightly with French Grey 70%.

Deepen all French Grey 70% areas with Dark Brown, including the outlines, to help blend the dragonfly into the finished painted piece.

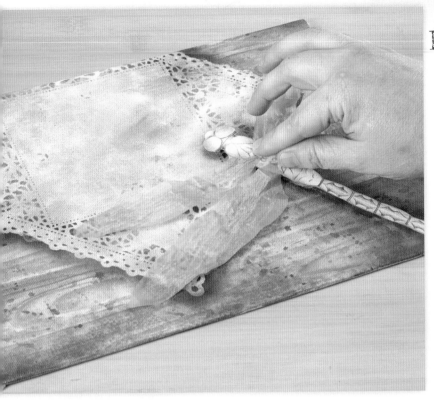

Adhere the Dragonfly and Add Wings Made of Sewing Pattern Paper

Cut out the dragonfly with sharp scissors. Cut out a cardboard dragonfly shape, a bit smaller than the colored dragonfly, so it will fit inside the dragonfly shape and be undetectable. Glue the cardboard to the back of the dragonfly body. Glue a couple of pieces of cardboard scraps together and glue them to the cardboard to add a little more height to the dragonfly.

Cut wings out of sewing pattern paper. Apply White colored pencil on top of the wings in random spots to brighten them. Crumble the wings, then flatten them out and glue to the body. When the wings are dry, glue the dragonfly to the canvas.

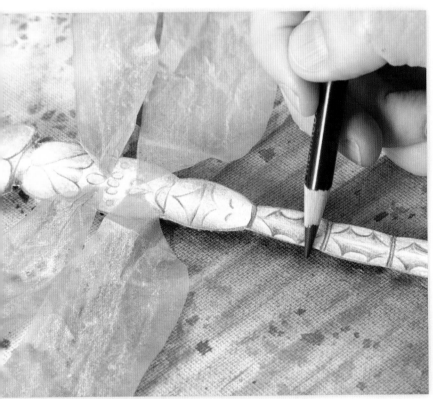

Shade Around the Dragonfly and Seal with Fixative

Run the Dark Brown pencil around the edges of the dragonfly to cover any stark white spots. Seal both the canvas and the dragonfly with a fixative.

4 LIFE OF THE HIVE

Imagine you are hovering over a large Earth city in your spaceship. You see people scurrying to and fro on sidewalks, police officers blowing whistles and moving their hands, children dashing into classrooms, adults entering offices, hospitals, and stores. You wonder if there is any order to this chaos. You are a patient, curious alien, and you observe that each person Eventually you see

So it is with a job to accomplish.
hive on of a
move what

like controls
scientists
different jobs;
don't know why
the bees are
their lives for the good
about the jobs of

Warm Honey

Having a father-in-law who is a beekeeper has made me fascinated with all things bees for many years now. The bee cutout was the inspiration for the piece, and the rest was designed around it. I wanted a strong symbol yet a subtle texture to accompany its great shape. The book page was an added bonus, and I love the feeling and movement of warm honey this piece of art evokes.

Materials

9" × 12" (23cm × 30cm) canvas panel

book, dictionary page

brushes: no. 5 round, ½-inch (13mm) DM stippler

cardboard scraps or wooden buttons

chipboard

clear glue

container of water

DecoArt acrylic paints in Dark Chocolate, Honey Brown, White

gesso

Golden Light Molding Paste

honeycomb template

Krylon Workable Fixatif

matte medium

palette knife

paper towel

pencil and sharpener

Prismacolor Colored Pencils in Dark Brown, French Grey 70%, Goldenrod, Sienna Brown, Yellow Ochre

scissors

scraps of scrapbook paper

scrap of tulle

stencils: Crafters Workshop mini splats, Stampers Anonymous burlap, Heidi Swapp honeycomb

toothbrush

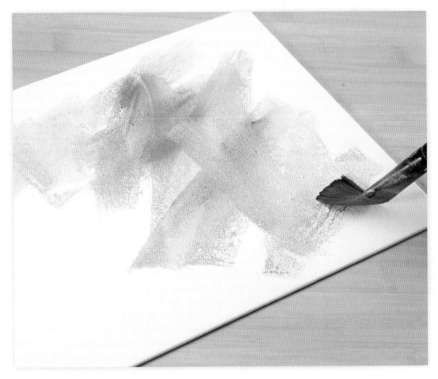

1 Paint the Background Color
Dampen the canvas panel with water, then apply Honey Brown paint with loose X strokes.

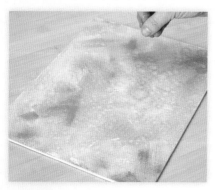
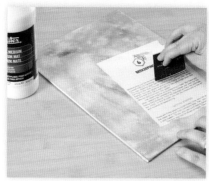
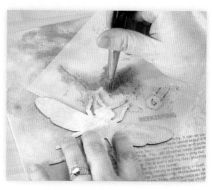

2 Splash Water on the Canvas for Texture

Let the paint dry for about 10 seconds, then dip your fingers into water and splash it onto the canvas. Let the water sit until the shine leaves, then blot lightly with a paper towel. Repeat this splash technique until you're satisfied with the look (about three times for me).

3 Adhere the Book Page

Find a book page you like (dictionary, field guide, book about bees), rip it out and tear it down to the size you want it to be. Apply matte medium to the area on the canvas where the page is going. Adhere the book page with clear glue and smooth it out using a spreader, working from the center out to remove any air pockets. Allow the page to dry then apply matte medium on top of the page. Allow it to dry again. Repeat step 1 and step 2 over the entire panel.

4 Gesso the Chipboard Bee and the Stencil Splat on Canvas

Decide where you plan to place the chipboard bee and the stencil splat. Cover the bee with one coat of gesso, but don't glue it down (you'll add details to the bee with colored pencil later). Paint through the stencil with Honey Brown.

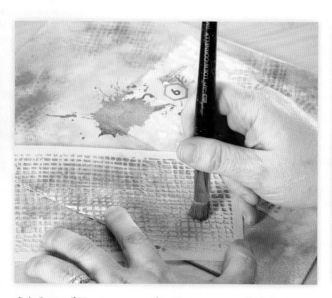
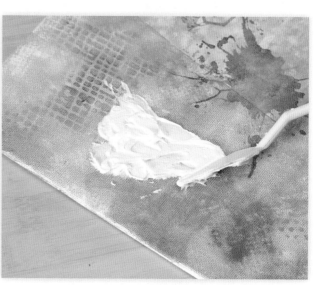

5 Stencil Textures on the Canvas

With the burlap stencil and a scrap of tulle, apply patterns with the DM stippler brush and Dark Chocolate in a hit-and-miss pattern. You don't want to do the exact shape of the stencil—the stenciling looks more unique when moved around.

6 Cut Out Hexagons and Spread Molding Paste on the Canvas

Using the honeycomb stencil (or freehand a hexagon shape), trace the design onto scrapbook paper (double-sided sheets are best because you get two designs with one cut) with a pencil and cut them out. You will need about forty pieces depending on the size of your honeycomb. Then apply a generous layer of molding paste to the canvas panel with a palette knife. Make sure you have a thick enough layer so the paste will squeeze out when you place the hexagons down. The bottom area of the honeycomb will be larger than the one at the top.

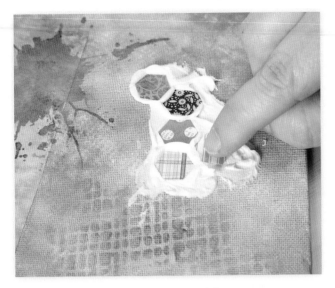

Press Hexagons Into the Molding Paste

Spread out the hexagon shapes and press them firmly into the molding paste, one by one. Work next to one another so the shape stays honeycomb-like. Apply hexagons until you're happy with the size of the honeycomb.

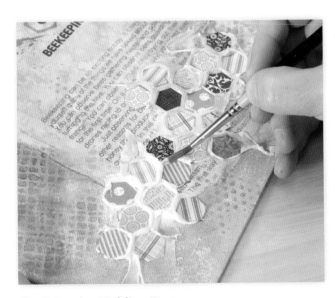

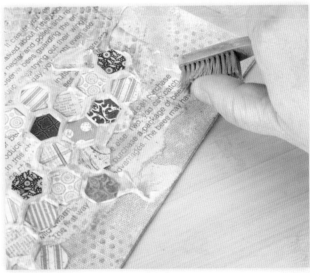

Paint the Molding Paste

When the molding paste is dry, apply one coat of matte medium over each paper hexagon inside the honeycomb.

Using a no. 5 round brush with a watery wash of Honey Brown, paint over the molding paste honeycomb. Use a small clean, damp brush to wipe excess paint off the paper pieces.

Spatter Paint on the Canvas

Spatter the piece by running your fingers over the bristles of an old toothbrush loaded with watered-down Honey Brown. Deepen some of the edges with Dark Chocolate. Touch the honeycomb here and there with Dark Chocolate.

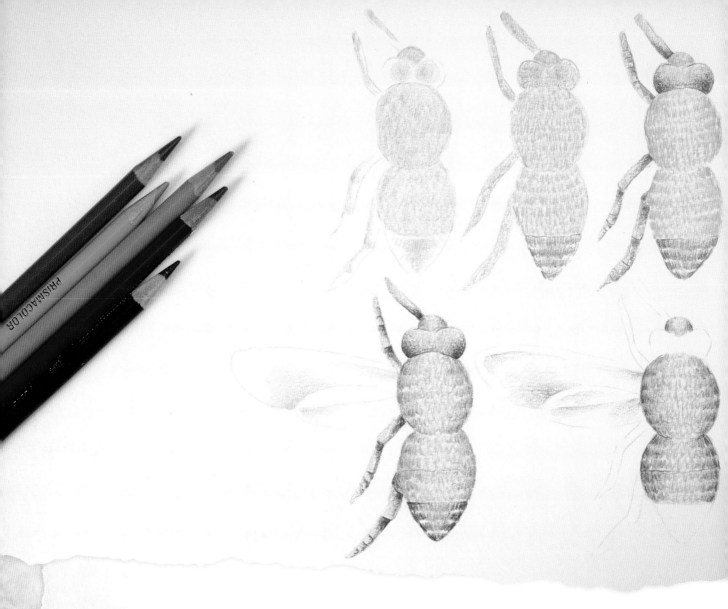

10 Draw the Bee on the Chipboard

Create the colored pencil bee design on the chipboard. Apply White paint to the head, body and tail. All bee details are done with colored pencils as follows.

11 Color the Lightest Bee Shades

Fill in the head, body and top two tail sections with circular strokes of Yellow Ochre. Sharpen the pencil, then do linear strokes of Yellow Ochre for hair on all the sections.

12 Deepen the Bee Shading

Shade the outer edges using Goldenrod with linear strokes at 30% pressure, letting them fade into the center. Do this step twice. Deepen the shading with Sienna Brown linear strokes staying just at the edges.

Deepen the edges with Dark Brown. Lay the bee on the painted piece to see if your values need to be darker overall. If so, strengthen the Sienna Brown and Dark Brown strokes.

13 Add the Tail Details

On the third tail section apply Yellow Ochre to the center with linear strokes. Fill the section with French Grey 70%. Add shading with French Grey 70% and deepen with Dark Brown.

14 Add the Head Details

The eyes, antennae, legs and arms are highlighted with Yellow Ochre. Go over the highlights and fill the rest of these shapes, shading with French Grey 70% and deepening with Dark Brown.

15 Color the Bee Wings

Shade the wings with Goldenrod, then deepen the shading with Sienna Brown.

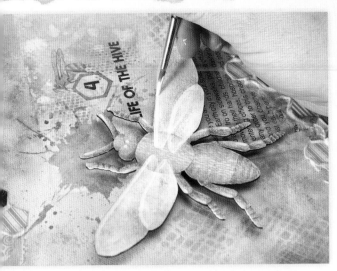

16 Highlight the Bee and Seal with Fixative

Highlight the wings and eyes with white paint. Where the arms and legs are colored with Yellow Ochre, highlight lightly with white paint. With white, line each wing at the top edge. Float the outer edges away from the body to add wing sparkle. Shade each wing with French Grey 70%.

Spray the canvas and bee with fixative. When the fixative is dry, glue cardboard scraps or wooden buttons to the back of the chipboard bee, then glue the bee to the canvas.

Shading

Spend time practicing your shading for added depth in your art pieces.

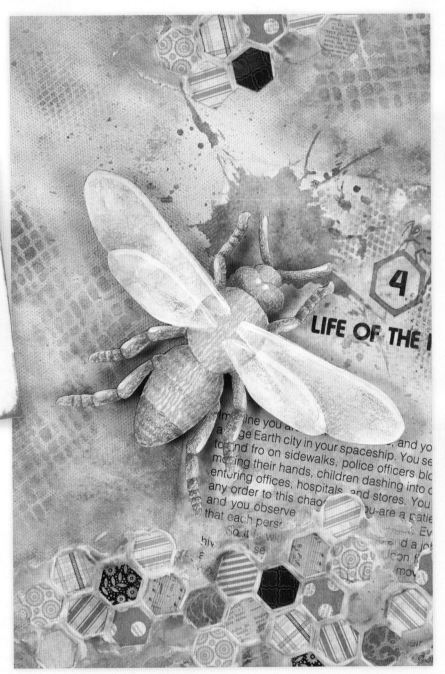

Visit CreateMixedMedia.com/colored-pencil-collage for bonus materials.

5 Surfaces

Exploring different surfaces or substrates is a must for any creative artist. You have to find what you like to create on and what you can do with it. Trying out a variety of surfaces you have around the house should be the first place to start. Look around. I bet you can find something wooden, a tin piece, fabric, a recycled item. Yes, it all starts there. Grab one and try your hand at using the medium you like to work in.

I like to work on unsealed wood because of the way it grabs the acrylic paint and creates a lovely tension that I can feel in each and every brushstroke. Fabric is a bit smoother but does have an interesting tooth to it when adhered to something else. Recycling or repurposing is something I am truly enjoying at the moment because I am giving a discarded item new life, adding another dimension to the art that is created on it.

In this chapter you will find fun projects to try using everything mentioned above. Look around and see what you can use—we can make it work. There are some easy and quick prep steps, then the rest is all about your ideas, creativity and your willingness to play. Have fun!

sur·face ‖ noun
1. the outside part or uppermost layer of something (often used when describing its texture, form or extent).
"the earth's surface"
synonyms: outside, exterior; top, side; finish, veneer
"the surface of the door"
2. geometry: a continuous set of points that has length and breadth but no thickness.

‖ adjective
1. of, relating to, or occurring on the upper or outer part of something.
"surface workers at the copper mines"
synonyms: superficial, external, exterior, outward, ostensible, apparent, cosmetic, skin deep
"surface appearances"

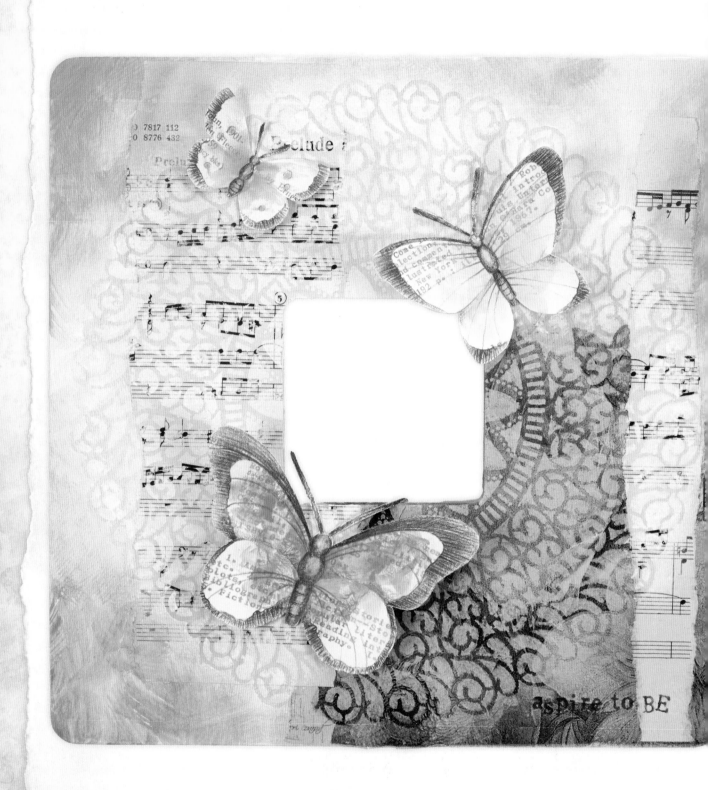

Poetic Rhapsody

I knew I wanted to do a trio of butterflies and went looking through my stash and found a perfect backdrop in a paper napkin. I let it dictate the color, the mood and the paper ephemera but most of all the lovely movement of the butterflies. It's as if they are dancing to a rhythm heard only by them. I love this project because it has a very feminine feel, something my work doesn't always reflect.

Materials

10" (25cm) square wooden frame with 3½" (9cm) opening

brushes: 1-inch (25mm) wash, ½-inch (13mm) DM stippler

butterfly template

clear glue

craft knife

DecoArt acrylic paints in Fawn, Flesh Tone, Terra Cotta, White Wash

gesso

Krylon Workable Fixatif

library cards

masking tape

matte medium

old credit card, room key or spreader

palette or palette paper

paper towel

plastic doily or large stencil

printed paper napkin

Prismacolor Colored Pencils in Espresso, French Grey 70%, White

sandpaper

scissors

sheet music or book pages

stamp ink

stylus

word stamp

Wood ‖ noun
1. the hard fibrous material that forms the main substance of the trunk or branches of a tree or shrub.
2. an area of land, smaller than a forest, that is covered with growing trees.
"a thick hedge divided the wood from the field"
synonyms: forest, woodland, trees; copse, coppice, grove, bush, woodlot
"a walk through the woods"

Butterfly detail

Prepping Wood

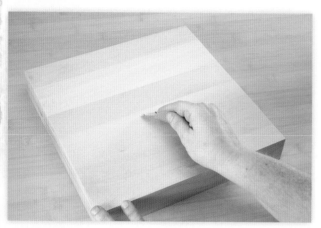

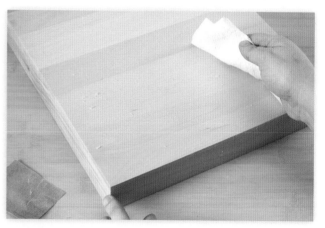

1 Sand the Wooden Board

Sand in the direction of the wood grain using a fine-grit sandpaper until the wood is smooth.

2 Wipe Away Dust

Wipe away the wood dust using a damp paper towel. Repeat steps if needed.

Demonstration

Butterfly Frame

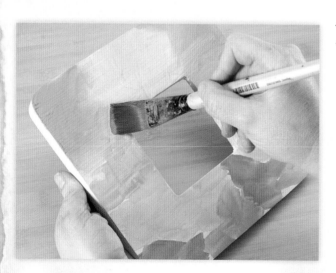

1 Paint Background Colors

After cutting out a square in the center of your board, apply one coat of gesso to the entire frame. When it's dry, pour quarter-sized puddles of Flesh Tone, Fawn and Terra Cotta paint onto your palette. With the 1-inch (25mm) wash brush and loose X strokes, add Flesh Tone in three places around the frame. Rinse the brush, then feather the paint edge lightly to keep it damp for easy blending with the next color. Add Fawn in the same manner followed by Terra Cotta. Make sure to carry the colors over to the edges. You want nice soft edges where the colors blend or meet up next to one another. If you have hard edges, you can wipe them with a paper towel or let the paint dry and apply a light layer of gesso over top.

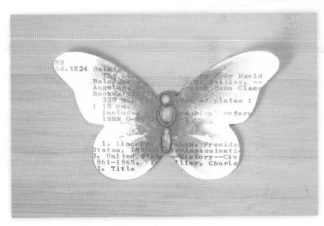

2. Make Three Butterflies Using Library Cards

Apply one coat of gesso on three library cards. Fold the library cards in half and cut out three varying sized and shaped butterflies.

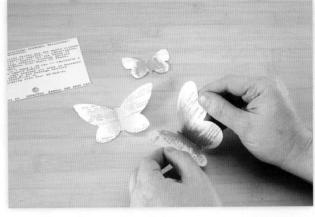

3. Add Color to the Butterflies

The technique is the same on all butterflies, only the color varies. Apply a watery mix to one side of the butterfly wing, leaving the outer edge blank, then press the other wing on top. When open, you should have a mirror image. The smallest butterfly is Fawn colored, the medium Flesh Tone and the largest Terra Cotta. Set aside to dry.

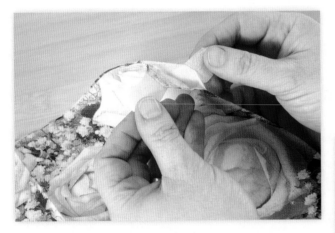

4. Separate a Patterned Napkin

Separate the napkin layers by using masking tape on the top layer corner and on the bottom layer corner and pulling apart. Repeat on the next layer if the napkin is three-ply, otherwise you will have a wrinkled mess when adhering the paper to the frame.

5. Adhere the Napkin to the Frame

Rip down the designed napkin layer to a size that will fit on a portion of the frame. Apply matte medium on the wood piece and gently lay the napkin down, smoothing it with your fingers immediately. I carried the napkin over to the edges to create a design element there as well. Allow the adhesive to dry, then apply matte medium over the top of the napkin. Let this dry.

It's Delicate

You have to let the surface dry before applying matte medium because the napkin is too delicate to handle the moisture of two layers.

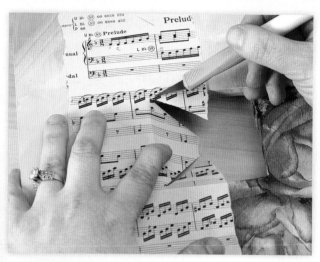

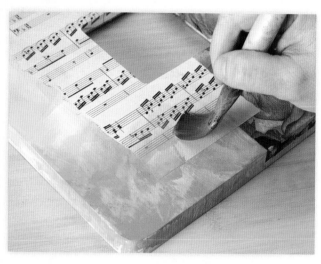

Collage on the Music Paper

Rip sheet music or book pages to a width you like. Apply matte medium to the board, lay down the paper and press it with a spreader to eliminate bubbles. I adhered the paper on the left to the top edge and on the right to the bottom edge to create a bit of movement. The paper will overlap the center hole, so cut the paper at the corners using a craft knife and wrap the flaps toward the center. Adhere the flaps with matte medium. Let it dry, then apply matte medium over the top of the paper to seal it.

Blend Collage Papers with Matching Paints

Paint washes of coordinating background colors over the pages to blend them into the design. Let some of the paper remain its original color.

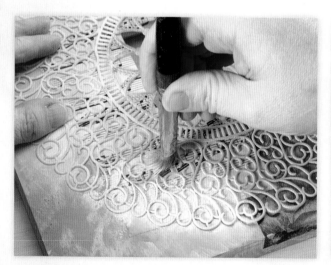

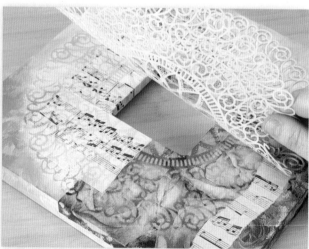

Pounce Through the Doily with One Color

Place a plastic doily or stencil on the frame. With the DM stippler brush and White Wash paint, start pouncing on the design. When you get to the napkin, switch to Flesh Tone paint just to give it a different look.

Add More Stenciling with Other Colors

Using the same colors as in step 8, paint the outer edges of the stencil by loading half of the brush with color and keeping the color next to the doily and the water half to the outside. This will create a nice gradual value.

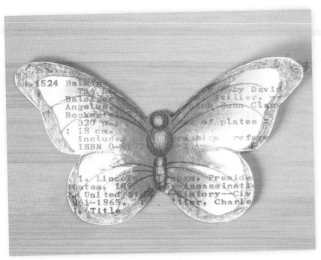

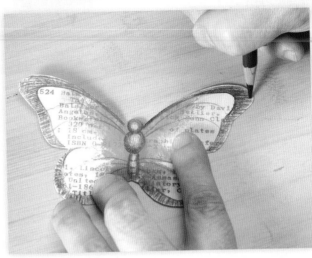

10 **Draw on the Butterflies with Colored Pencils**
Create a circle head, circle body and cylinder tail on the butterflies using French Grey 70%. Highlight each section with White in the centers. Using French Grey 70%, shade each section along the outer edge, getting lighter as you head into the white area.

Each butterfly has a different wing treatment. The edges of the small butterfly's wings are French Grey 70% lines. The edges of the medium and large butterflies' wings are filled with circular strokes of French Grey 70% first, then lines of French Grey 70%. The small butterfly has spots inside the wings outlined with a light touch of French Grey 70%. The medium and large butteflies' wing vein lines are done with a very sharp French Grey 70%.

11 **Deepen the Colored Pencil Shading**
Deepen the body and tail shading with Espresso. The antennae are filled with French Grey 70% deepened with Espresso at the tip and near the head.

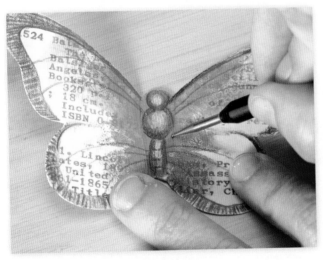

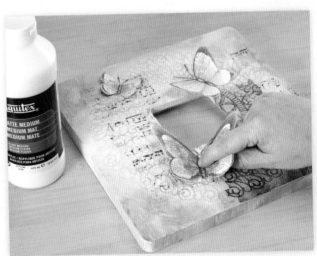

12 **Score and Fold the Butterfly**
With a stylus, score the butterflies where the body and wings meet then fold the wings up as if they are fluttering. Seal the frame and the butterflies with fixative. Move the butterflies around until you are happy with the movement they create in the design.

13 **Adhere the Butteflies and Add Stamping**
Using clear glue, apply glue to the flat body parts of the butterflies and adhere them to the frame. Make sure the wings are up as the glue dries.

Using ink and a stamp of your choice, stamp words in the bottom right-hand corner, then add antennas if desired.

Perfect Harmony

It all started with the idea of creating a harmonious design using a few striking elements that would command your attention. The swallowtail butterfly was perfect because of its great form and beautiful color. The crocheted doily adds such a wonderful texture and surprising element that you just have to try it.

Materials

6¾" × 5" (17cm × 13cm) oval wood shape

9" × 12" (23cm × 30cm) canvas panel

Adirondack Color Wash in Espresso

atlas or map page

butterfly template

clear glue

container of water

craft knife

crocheted doily

cutting mat

DecoArt acrylic paints in French Vanilla, Sea Glass, Shading Flesh

gesso

Krylon Workable Fixatif

light-colored fabric with writing

matte medium

newspaper

old credit card, room key or spreader

painter's tape

paper towel

pencil or black transfer paper

Prismacolor Colored Pencils in Dark Brown, Goldenrod, Jasmine, Lemon Yellow, Light Umber, Muted Turquoise, Sepia, Yellow Ochre

ruler

sandpaper or emery board

scissors

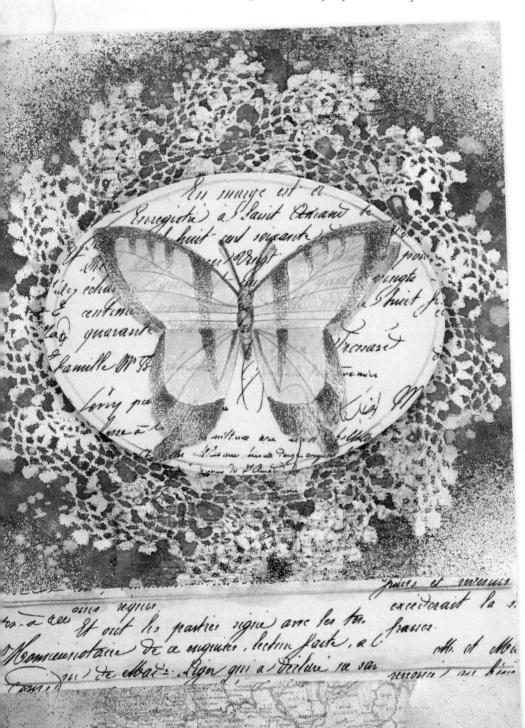

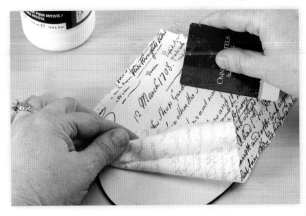

1. Sand the Wood and Adhere the Fabric

Prepare the wooden oval by sanding it. Apply matte medium to the wooden oval, then smooth a piece of fabric on top. Let it dry.

Cut a fabric strip 1½" × 9" (4cm × 23cm) to use later.

fab·ric || noun
1. cloth, typically produced by weaving or knitting textile fibers. "heavy silk fabric"
synonyms: cloth, material, textile, tissue
"the finest silk fabric"
2. the walls, floor, and roof of a building.
synonyms: structure, infrastructure, framework, frame, form, composition, construction, foundations, warp and woof
"the fabric of society"

Background Color

For a stronger white background, apply one coat of gesso to the wood before adhering the fabric on top.

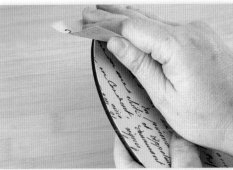

2. Trim off Excess Fabric

When the fabric is dry, lay the wood face-down on a cutting mat. Applying pressure to the wood, cut off the excess fabric using a craft knife.

3. Smooth the Edges of the Wooden Oval

Smooth the edges of the fabric and board using an emery board or piece of fine sandpaper.

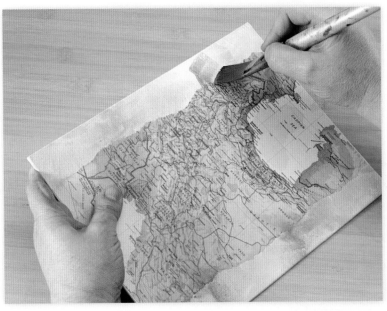

4. Adhere the Atlas Page to the Canvas and Add Matching Paint

Rip an atlas or map page so it comes in approximately 1¾" (4cm) from each side of the canvas. Adhere the paper to the canvas with matte medium, and smooth out air bubbles using a spreader working from the center out. Allow the glue to dry, then apply matte medium over the top of the page and allow it to dry again.

Extend the map to the edges of the canvas using paint colors that match the map colors as best you can. I used French Vanilla, Sea Glass and Shading Flesh. Work one color at a time. While the paint is still wet, splash water over the surface, then blot it lightly with a paper towel, exposing brighter color spots.

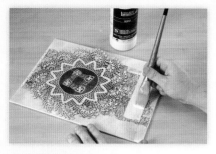
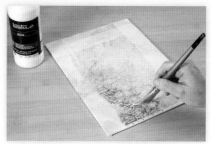

5 **Block out the Doily and Paint a Gesso Stripe**
Decide where the doily will go and create a gesso stripe about 1½" (4cm) wide near the bottom of the panel.

6 **Cover the Whole Board with Gesso**
When the gesso stripe is dry, apply one coat of gesso over the entire board. The gessoed stripe will be brighter than the whole piece.

7 **Trace the Butterfly and Paint It with Gesso**
Trace the butterfly template onto the fabric oval using a pencil or black transfer paper. Apply one coat of gesso to each wing and allow to dry.

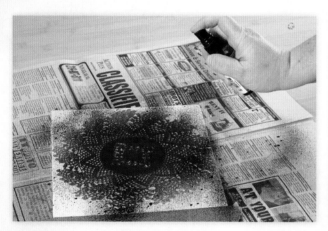
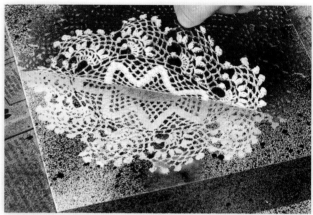

8 **Place the Doily and Spray Color Wash**
Spread out newspaper on a table, then position the canvas panel in the center. Cover the 1½" (4cm) stripe with painter's tape to create a mask. Burnish the edges well to ensure the spray doesn't seep under the tape. Lay a crocheted doily on the top portion of the canvas panel and smooth it out. Using the Adirondack Color Wash, spray all over the doily, making it as even as possible.

9 **Remove the Doily and Blot with a Paper Towel**
Remove the doily and blot the canvas lightly with a paper towel. Spatter with finger splashes of water, then blot again.

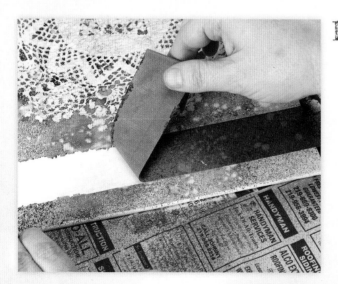

10 **Remove the Tape to Reveal the Gessoed Strip**
Remove the painter's tape where the fabric strip is going to go. If any paint seeped under the tape, wipe it off with a damp paper towel. It may take several wipes to remove it all. Apply two coats of gesso to whiten the strip, then adhere the fabric strip with matte medium. When the fabric is dry, apply matte medium over the fabric strip.

11 Begin the Butterfly with Lightest Shades

Color the butterfly over the gesso on the fabric-covered oval using colored pencil. Fill in the wing areas with two layers of Jasmine at about 50% pressure. Brighten the wings with two layers of Lemon Yellow.

Pencil in vein lines and start shading along them with Yellow Ochre values twice, then Goldenrod values.

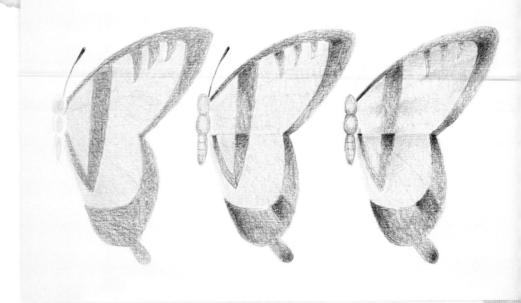

12 Deepen the Coloring with Browns

Fill in all the brown as shown above with Light Umber using circular strokes twice. Shade the area with Dark Brown. Deepen the wings with Sepia and go over the veins with a sharp Light Umber.

13 Add Highlights and Shadows

The body is highlighted with Jasmine. Cover the Jasmine and fill the bodies using Light Umber values. Shade the body with Dark Brown and deepen with Sepia. The antennae are also colored with Dark Brown followed by Sepia.

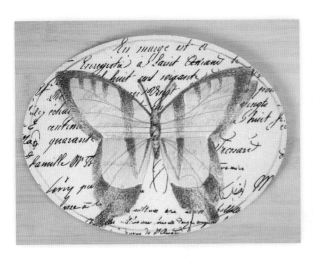

14 Adhere the Fabric and Shade Around the Butterfly

Color shadows around the butterfly here and there using Muted Turquoise. Touch in Sepia in a few places to deepen the shadows. Draw a border around the oval with Muted Turquoise.

15 Seal with Fixative and Adhere the Butterfly Oval

On the fabric strip, use a ruler and Muted Turquoise to draw a double stripe on top and a single stripe on bottom. Spray fixative over the canvas and the oval, then glue the oval to the center of the doily image.

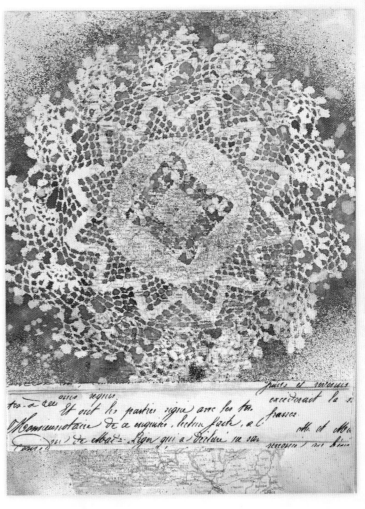

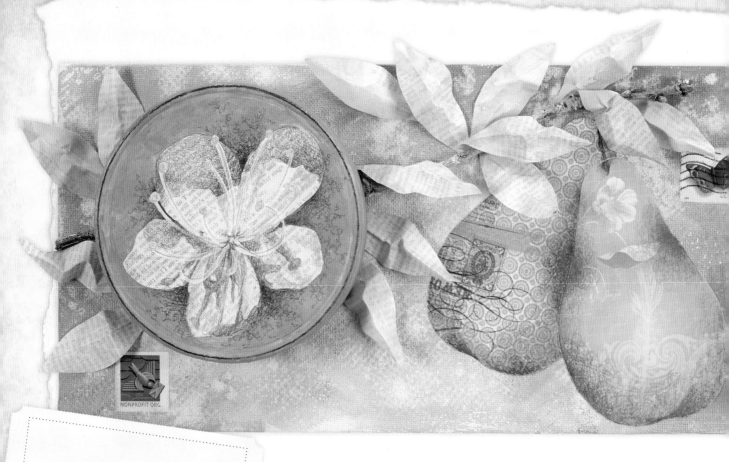

Delicious Rendition

The idea of using something destined for the trash is a great way to recycle and give new life to an object. The fun circle in this piece is just an empty cheese box. I was inspired to use scrapbook papers, a few book pages and twigs from my yard to complete this delicious piece.

Materials

12" × 6" (30cm × 15cm) canvas panel

blossom and pear templates

book pages

brushes: 1-inch (25mm) wash, no.16 shader, no. 5 round or no. 1 liner

cancelled postage stamps

clear glue

container of water

craft knife

cutting mat

DecoArt acrylic paints in Jade Green, Sea Glass, White Wash

gesso

Krylon Workable Fixatif

masking tape

matte medium

newsprint

old credit card, room key or spreader

paper towel

pencil or black transfer paper

Prismacolor Colored Pencils in Artichoke, French Grey 90%, Goldenrod, Green Ochre, Limepeel, Sienna Brown, Yellow Ochre

recycled cheese box (e.g. President brie, Laughing Cow Swiss)

scissors

scrapbook papers

table salt

twigs

re·cy·cle ‖ verb
1. convert (waste) into reusable material.
"car hulks were recycled into new steel"
synonyms: reuse, reprocess, reclaim, recover; upcycle; salvage, save
"the UPS Store will recycle those annoying styrofoam peanuts"
2. return (material) to a previous stage in a cyclic process. Use again.
"he reserves the right to recycle his own text"

1 Fill the Box and Tape It Closed

Fill a cheese box with newsprint and be sure to stuff it firmly. Close the box and tape along the entire edge to seal it with masking tape. Try to make the tape seal as seamless as possible.

2 Adhere a Book Page to the Top, Cover the Box with Gesso

Trace the top circle onto a book page and cut it out. Apply matte medium to the box top and adhere the book page to it, smoothing out all air bubbles. When the matte medium is dry, apply one coat of gesso over the entire box.

3 Paint the Background on the Canvas and Blot to Dry

Dampen the canvas panel with water, then paint Sea Glass in the center and Jade Green to the outer edges. While the paint is wet, sprinkle on table salt. Splash water on the paint with your fingers and let it sit for a couple seconds until the shine starts to leave. Blot the canvas gently with a paper towel but don't wipe off the salt.

Finger splash the canvas again and blot. When the paint is dry, wipe off the salt.

Give It Some Tooth

If the box is shiny or has any metallic pieces, you will need to sand it before applying the matte medium coat.

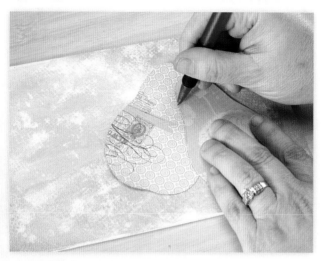

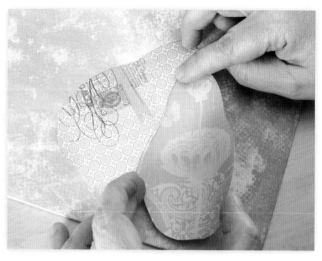

4 Cut out the Pear Shapes

Using a cutting mat and a craft knife, cut out two pears (Delicious Rendition template) from different scrapbook papers. Position them where you like on the canvas, then draw around the top one where it overlaps the other. Cut this section out so both pieces will lie smooth when you begin to add colored pencil rendering on top.

5 Adhere the Pears to the Canvas

Glue the pears to the canvas with matte medium, smoothing out air bubbles. When the pears are dry, apply matte medium on top. The layer of matte medium on top of the pears will allow the wax of the colored pencils to be more easily blended in later steps.

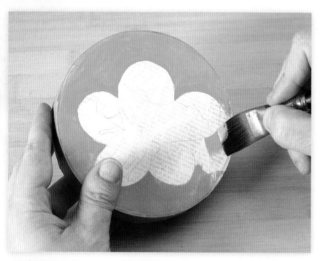

6 Draw the Blossom on the Box and Paint Around It

Transfer the blossom template to the cheese box lid and paint one coat of Jade Green to the background, sides and bottom of the box, taking care to go around the blossom outline.

7 Gesso Book Pages and the Twigs and Set them Aside

Gesso two book pages and the twigs. These will be used for the leaves later on in the project. Set aside to dry.

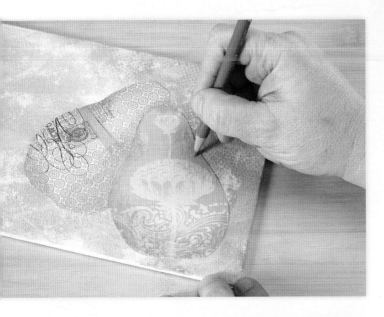

8 Begin Shading the Pears with Colored Pencils

Begin to add colored pencil shading to the pears. The yellow pear gets shading with Goldenrod and the green pear with Limepeel.

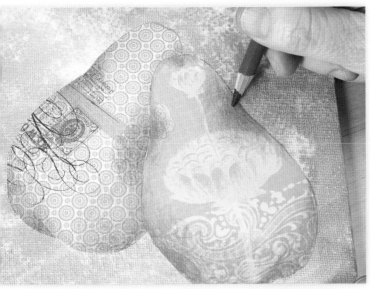

9 Deepen the Shading of the Pears

Deepen the shading of the yellow pear with Sienna Brown and the green pear with Artichoke.

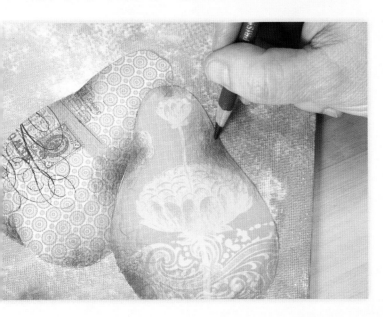

10 Add the Deepest Pear Shades

Further deepen the shading of both pears with Green Ochre. Make sure the pear in the back is shaded more deeply to both emphasize and draw the top pear forward.

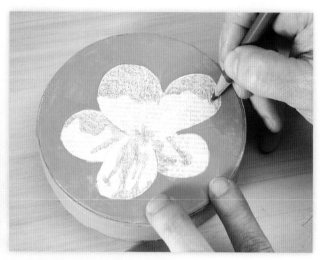

11 Begin Coloring the Blossom

Moving back to the box, start shading the blossom with Artichoke.

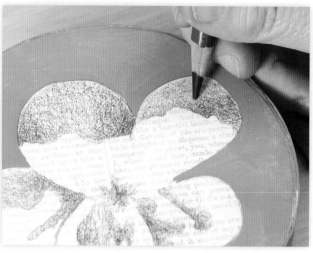

12 Deepen the Shading of the Blossom

Deepen the shading of the blossom with Green Ochre, creating nice soft values.

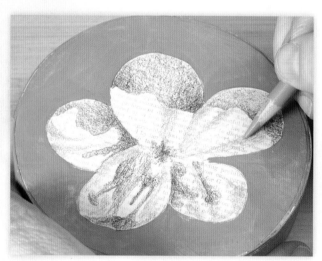

13 Add Yellow Highlights

In the light areas of the blossom, shade with Yellow Ochre.

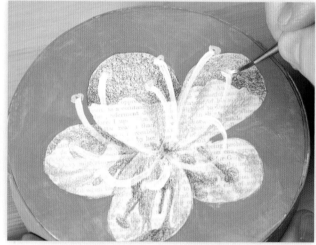

14 Paint White Highlights on the Blossom

Using White Wash paint and a no. 1 liner brush, paint in the stamen with graceful curves that point toward the center of the flower. You might have to do this step twice. Paint small white circles at the ends of each stamen.

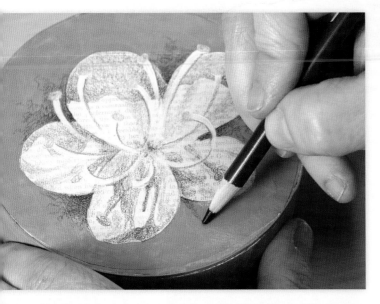

15 Shade Around the Blossom

Fill the circles at the ends of each stamen with Yellow Ochre and shade them with Goldenrod. Add lines of Artichoke to each stamen to give weight to them.

Shade the outer edges of the petals (on a green background) with French Grey 90% values. Let your pencil strokes show into the background to resemble smoke or a fine crackle. Rim the edge of the box by laying a French Grey 90% pencil flat and turning the box until you complete the circle.

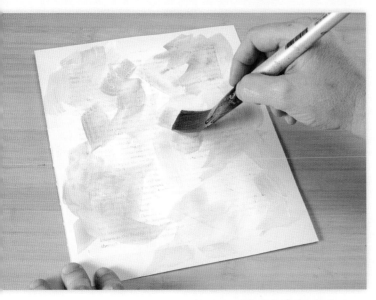

16 Gesso and Paint the Old Book Pages, Cut out the Leaf Shapes

On the gesso-covered book pages, apply loose random paint strokes of Sea Glass and Jade Green. When the paint dries, fold the paper in half lengthwise and then in thirds (accordion-style folding). Trace or draw a leaf shape to one section and cut it out with scissors. Each leaf should be creased in half and wrinkled to add shape and interest.

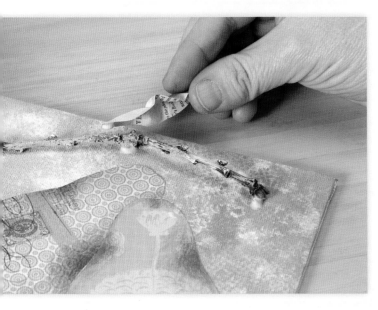

17 Adhere the Box, Twigs and Leaves to the Canvas, then Seal with Fixative

Glue the twigs and the box to the canvas. Spray the whole piece with fixative.

Dip the bottom edge of a leaf in glue and adhere it to the design. Continue adding leaves, working one leaf at a time until you are satisfied. Glue a couple of postage stamps to the board with matte medium to complete the design. If the stamps are too bright, wash over them with a background color.

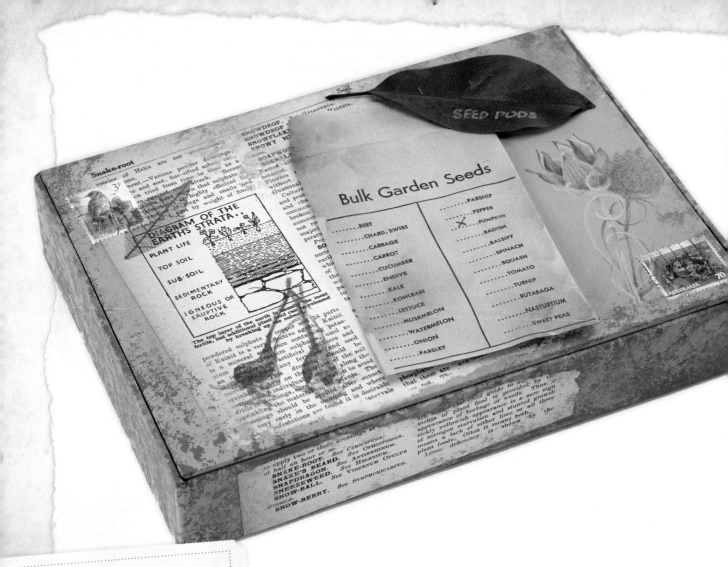

Season's End

I love seedpods and all the wonderful shapes and sizes they have. I find the season's end in the garden almost as wonderful as the variety of colorful blooms, only because I know these pods contain next year's growth. I wanted to create a little treasure box to include my garden finds but make it pretty enough to stay out all year long.

Materials

book pages

brushes: 1-inch (25mm) wash, no.1 liner

cancelled postage stamps

clear glue

DecoArt acrylic paints in Driftwood, Mississippi Mud

empty toilet paper roll

Krylon Workable Fixatif

matte medium

old credit card, room key or spreader

palette paper

pebbles or twig pieces

plastic and skeleton leaves

pod shape template

Prismacolor Colored Pencils in Crimson Lake, Dark Brown, French Grey 90%, Jade Green, Kelp Green, Light Umber, Mahogany Red, White, Yellow Ochre

recycled cigar box

sandpaper

scissors

sea sponge

seed packet or envelope

white gesso and clear gesso

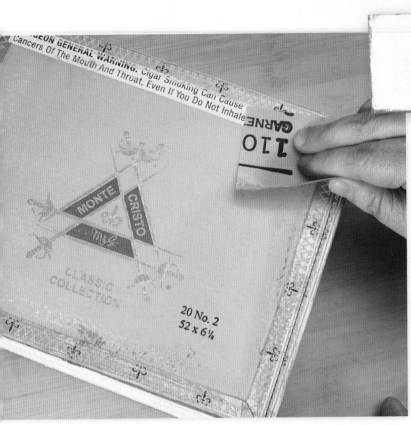

re·pur·pose || verb
1. adapt for use in a different purpose.

1 Sand the Recycled Cigar Box and Cover It with Gesso

Lightly sand off any metallic areas from the cigar box. Cover the entire box with one basecoat of white gesso.

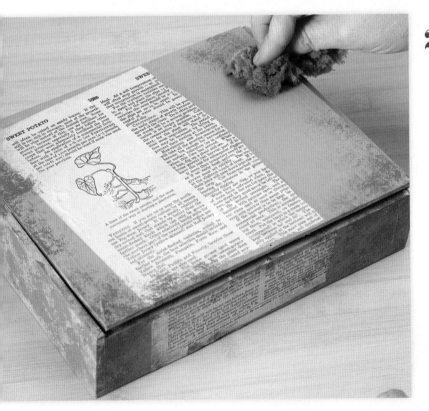

2 Decorate the Box with Paint, Book Paper and Sponging

Place an empty toilet paper roll (or other found object) inside the box to slightly prop up the lid while you paint. This will keep the paint from sealing the box closed. Cover the entire box with two coats of Driftwood paint. Adhere a book page to the top and front side of the box with matte medium, smoothing it with a spreader to remove air bubbles. When the glue is dry, apply matte medium over the paper.

Dampen a sea sponge and blot it dry really well. Dip the sponge into Mississippi Mud, then pounce it onto palette paper to remove excess paint. Lightly begin sponging the top edges of the box. Use a heavier sponging hand on the sides of the box to give them more color than the top.

3 Prepare the Seed Packet

If needed, cut off the bottom of the seed envelope, then glue it shut. Apply one coat of clear gesso to the envelope to seal it without altering the color. When dry, apply watery Mississippi Mud to dirty it up. Fill the envelope with pebbles or twig pieces, then glue the envelope shut to keep the pieces inside.

4 Begin Drawing Seedpods on the Box

Transfer the pod shapes template to the front of the box. All the pods are done in colored pencil. The rose hips on the left are filled with Crimson Lake and the calyx are Jade Green. Color the stems with Light Umber.

The hibiscus stem and light pieces on the right are done with White, while the leaves are Jade Green. Color the pod hulls with Light Umber.

5 Color the Rose Hips

Shade the rose hip edges with Mahogany Red and the calyx with Kelp Green. Darken the stem with Dark Brown.

Deepen the color of the rose hips with Dark Brown then Kelp Green. Deepen the calyx with Dark Brown and the stem with Kelp Green.

6 Color the Hibiscus

Go over the entire white hibiscus stem with Yellow Ochre, the leaves with Kelp Green and the pods with Dark Brown, then lightly with Mahogany Red.

Shade the hibiscus stem using Light Umber, then Dark Brown lightly if needed. Deepen the hibiscus leaves with Dark Brown and the pods with a touch of Crimson Lake. Add seeds inside the lighter areas with Light Umber and shade them Dark Brown.

7 Add Shadows to Both

The shadows on both sets of pods are French Grey 90%, deepened with Dark Brown.

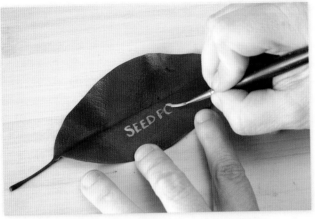

8. Paint the Leaves, Adhere the Leaves, Seed Packet and Stamps to the Box

With your liner brush and water-thinned Driftwood, write "seed pods" on a leaf. You can use rubber stamps and ink if you have them.

Adhere cancelled stamps within the design on the box. If they are too bright, wash over them lightly with Driftwood. Glue down the envelope and the leaves.

Spray the box with fixative. While the box is drying, leave the lid slightly ajar so it doesn't adhere to box edges.

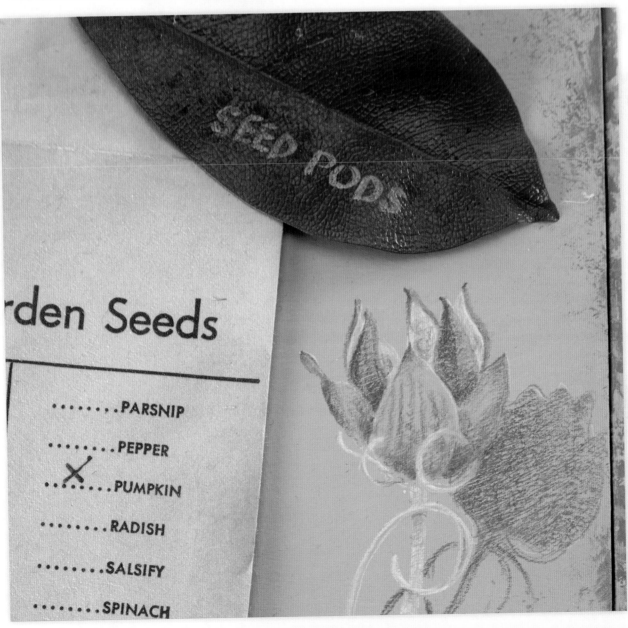

SEED PODS

rden Seeds

- PARSNIP
- PEPPER
- . . ✗ PUMPKIN
- RADISH
- SALSIFY
- SPINACH

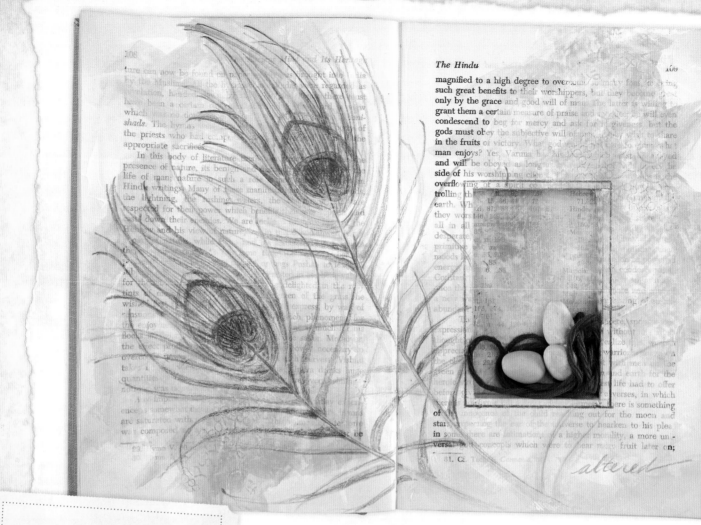

Altered Peacock

I found these neutral peacock feathers in the craft store and knew they would be a beautiful addition to any project. Then I started thinking about making them the art. So, how to showcase and give them their special space? An altered book seemed perfect. There would be space enough for them to spread out, yet there would also be space for a niche for something special—their start. I added little air-dry clay eggs to give us another fun surface to play with. Enjoy the altered book; it was a journey to create!

Materials

binder clips (6)

brushes: 1-inch (25mm) wash, no. 8 shader

clear glue

craft knife

Crayola Model Magic air-dry clay

cutting mat

DecoArt acrylic paints in Fawn, French Vanilla, Wasabi Green

gesso

Golden Regular Gel

Krylon Workable Fixatif

nest material (yarn, string, shredded paper, excelsior)

old credit card, room key or spreader

palette knife

paper towel

peacock feathers template

pencil

Prismacolor Colored Pencils in Chocolate, Dark Brown, Dark Umber, Ginger Root, Light Umber, Sandbar Brown

recycled book of your choice

ruler, metal with cork backing

sandpaper

scissors

spray bottle of water

sticky notes

Super Chacopaper transfer paper

table salt

texture item (stencil, bubble wrap)

waxed paper

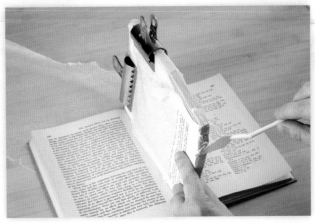

1 Determine the Niche, Glue the Pages Together

Find a spot in the book you want to work and mark those pages with sticky notes. The side where your niche will be placed should have more pages. Glue each of the marked pages to the page behind it using regular gel. Smooth the pages from the center outward using a palette knife or spreader depending on the book size. This will add stability to your pages so you can paint on them later.

2 Seal the Niche Pages Together

Define the page where you'll place your niche by holding the pages firmly together. Apply regular gel using the palette knife to cover the outer edges. Put a nice even coat on them, making sure the corners are very well done. After a section is glued, place waxed paper over the edge and use a binder clip to hold it in place. Once each side is complete, place binder clips near the spine and outer corners to give it a good shape when drying. Let the book dry at least eight hours. Unbind the pages and sand lightly if needed.

book ‖ noun
1. a written or printed work consisting of pages glued or sewn together along one side and bound in covers.
2. a bound set of blank sheets for writing or keeping records in.

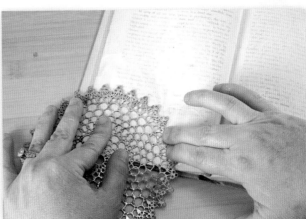

3 Gesso the Main Spread

Spread gesso on your working pages using a spreader.

4 Add Texture and Background Paint Layer

While the gesso is still wet, press in texture with a stencil in a couple of places. Let the gesso dry.

Spritz the pages with water then apply French Vanilla paint (more on the left page) and Wasabi Green (more on the right page), blending them slightly. While the paint is wet, add table salt. Let the paint dry for a couple of seconds, then finger-splash the pages with water. Blot the pages dry after the shine has gone away. Wipe the salt away and repeat the paint/water/salt process if more color is needed.

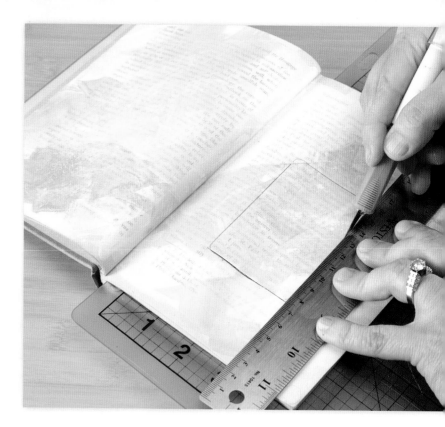

5 **Mark the Niche and Cut It Out**

Mark your niche with a pencil and ruler. Place a cutting mat behind the niche pages so you won't cut through to the remainder of the book. With a firm grip on the ruler, place it against the drawn line and begin cutting through the pages with a craft knife. Don't press down into the pages, just firmly glide the knife along the ruler. I do four to five strokes on each line, then take out the few pages the knife cut through.

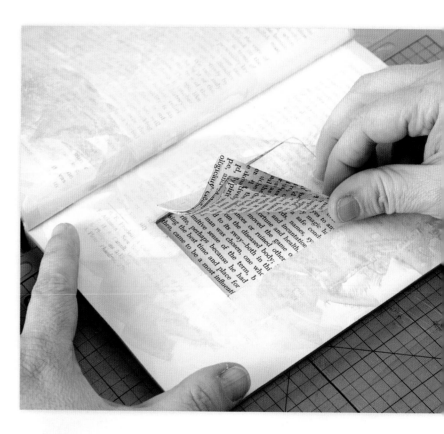

6 **Remove Niche Pages and Seal Them Together**

Repeat step 5 until you have cut through the entire niche, creating a hole. Gently clean out the corners with a craft knife until you are satisfied.

Glue the edges of the inside of niche (cut area) with regular gel and palette knife just like you did in step 2. Glue the back page of the book to the niche block. Put waxed paper over the page and weigh it down to make a nice firm inner area. Allow the pages to dry at least two hours.

Paint the inside of the niche using the same process as in step 4.

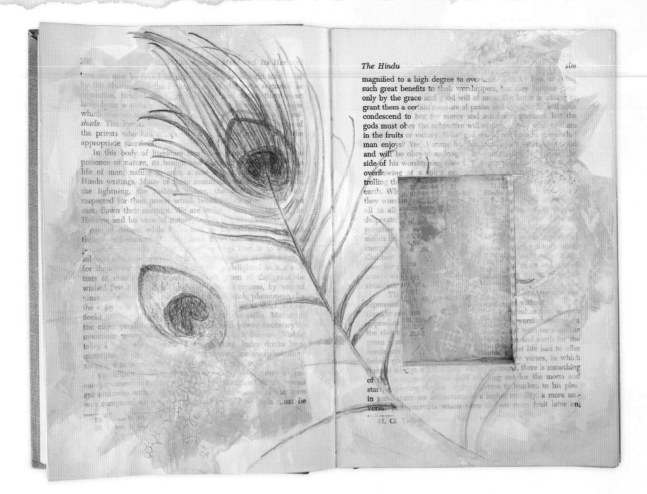

7 Transfer and Color the Peacock Feather Drawings

Transfer the peacock feather drawings from the template with Super Chacopaper, which is water-soluble. Follow the numbered area on the template for color application.

Color area 1 with Ginger Root, area 2 with Sandbar Brown, area 3 with Chocolate and area 4 with Dark Brown. Shade each area with the next darkest color. Areas colored with Ginger Root will be shaded with Sandbar Brown, the Sandbar Brown area with Light Umber, Light Umber with Chocolate, Chocolate with Dark Brown and Dark Brown with Dark Umber.

Separate the top of the feather with a line of Light Umber first, then deepen it with Dark Brown or Chocolate. Define the thickest areas of the feather center with Chocolate and shade with Dark Umber. Color the stem with Ginger Root, shade it with Sandbar Brown and deepen using Dark Umber.

8 Create and Color the Eggs, Create the Niche Nest

With air-dry clay, form three tiny eggs for your niche nest. The size will depend on the niche you made. When working with the clay, at any time you can put a bit of water on your finger and smooth out wrinkles or make the clay conform a little better. Allow the eggs to dry overnight.

Paint the eggs with one coat of Fawn and allow to dry. Create a nest in the niche from whatever material you gathered (yarn, string, shredded paper, etc.). First build a bottom layer and glue it in place with regular gel, then position the eggs and build the nest around it. Adhere each piece in place with clear glue.

SEA DRAGON

6 Paper Surfaces

pa·per || noun
1. material manufactured in thin sheets from the pulp of wood or other fibrous substances, used for writing, drawing, or printing on, or as wrapping material.
"a sheet of paper"
synonyms: writing paper, notepaper, bond paper, vellum, rice paper, tracing paper; graph paper; construction paper
2. an essay or thesis, especially one read at an academic lecture or seminar or published in an academic journal.
synonyms: essay, article, monograph, thesis, work, dissertation, treatise, study, report, analysis, tract, critique, exegesis, review, term paper, theme
"she has just published a paper"

Paper ephemera is quickly becoming a favorite of mine because of its availability. I have been collecting it from antique stores and thrift shops for the past year and really like the wide variety it offers. I am also a huge fan of words and feel they add so much to my art because I am picky about what I include when using dictionary or book pages. I want the viewer to discover the little message or meaning I have left uncovered in my art; it adds to the interest overall and I really appreciate that.

There are so many possibilities with paper as a surface. There are book pages that can be mounted and then worked into a design. You can use just a portion or a word to emphasize your art. Scrapbook papers also offer so many beautiful surfaces to inspire your creative muse.

Don't even get me started on art journals, art papers or watercolor papers! The reasons to try them all are numerous. My advice to you: Touch them to see what you like the feel of. I prefer texture, in fact I love it, so smooth paper is not even an option for me. Yes, I use book pages, but I like to put clear gesso on them to give them the feel of a rough, sandpaper-like surface.

We are each different so you have to find what speaks to your senses, what you like and dislike. Believe me, it won't take long before you have a favorite or two.

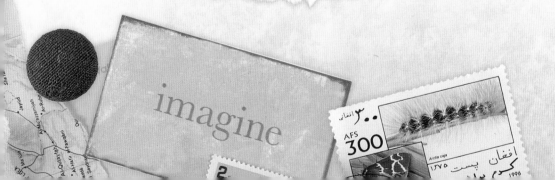

To Discover

I love to buy papers, and being inspired by their design, color and pattern is part of the fun for me. Mixing and matching, creating something new and making it creative is why I like working on scrapbook papers so much. Designing just the right thing to go on them is the challenge and one I look forward to quite a lot. The cork-board paper I used in this project made me think of things hanging in my studio: a short stubby pencil, a small paper butterfly and a little envelope full of stamps. Look around and see what you collect; the design is probably already there!

Materials

2 scrapbook papers

8" × 8" (20cm × 20cm) Masonite board

brushes: 1-inch (25mm) wash, no. 8 shader, no.1 liner, ½-inch (13mm) DM stippler

butterfly and pencil template

DecoArt acrylic paints in Charcoal Grey, White Wash

ephemera: word card, cancelled postage stamps, paper flower

Krylon Workable Fixatif

matte medium

old credit card, room key or spreader

paper towel

palette paper

pencil

Pink Paislee vintage lace mask stencil

Prismacolor Colored Pencils in Dark Brown, Goldenrod, Jasmine, Peach Beige, Sepia, White, Yellow Ochre

ruler

scissors

white or black transfer paper

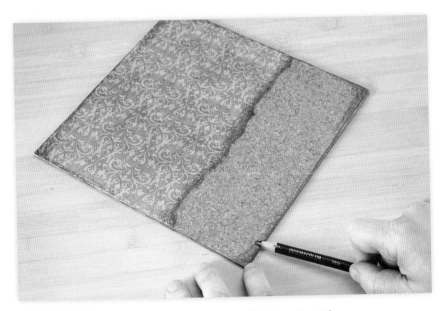

1 Adhere Background Paper and Shade It at the Edges

Cut the background scrapbook paper to the size of the Masonite board. Rip approximately a 2½" (6cm) wide strip of the secondary paper, then cut it to the height of the Masonite. Adhere the background paper to the Masonite with matte medium, smoothing the paper from the center out using a spreader. Wipe away the excess medium and apply a coat of matte medium on top. Allow the medium to dry, then apply matte medium to where the secondary strip will go. Adhere the paper and smooth it out with a spreader. Allow this strip to dry but do not cover it with matte medium because you will be adding colored pencil there, not painting.

With a Sepia pencil apply a value to the edge where the strip overlaps the background, giving it some depth. Keep it darker near the paper and lighter in value as it goes away from the paper. Using the side of the Sepia pencil, go around the whole perimeter of the square, letting it be messy and uneven.

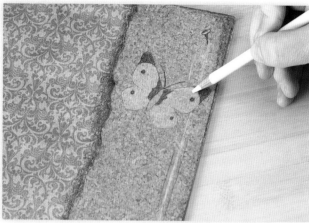

2 Transfer the Butterfly Pencil Drawing

Transfer the butterfly and pencil pattern template lightly with white or black transfer paper depending on your paper color.

3 Begin Applying Colored Pencil

With a Sepia pencil, outline then fill in the wing spots, the top of the wing tips, the pattern on both sides of the body and the antennae. Fill the rest of the wings with White, applying a heavy pressure. Fill the body with Peach Beige.

The twine and the center of the pencil is White. Fill the rest of the pencil casing with Jasmine then Yellow Ochre. The flesh of the pencil is highlighted with white. Fill the rest of the pencil with Peach Beige. The lead pencil point is colored with Sepia.

The thumbtack is highlighted with white, and the rest is filled with Sepia.

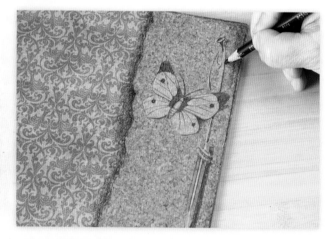

4 Add Details to Drawing Using Colored Pencils

Add wing veins with a very sharp Dark Brown pencil. The body is highlighted down the center with White. Shade the outer edges with Sepia, softly moving in toward the center. The body segments are created with Sepia lines done lightly.

Shade the pencil casing edges with Goldenrod and the center with Jasmine. On either side of the center use your ruler and a sharp Dark Brown pencil to put lines there.

Create shadows on the bottom right of the tack, twine, pencil and butterfly in Sepia.

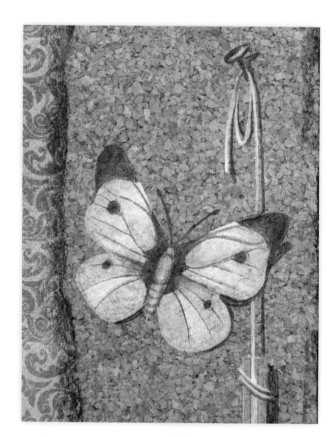

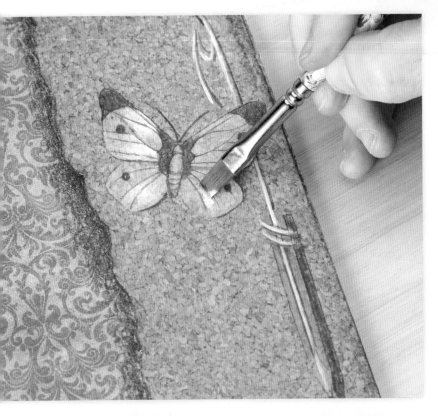

5 Add Highlights Using Paint

With White Wash paint and the no.1 liner, apply a highlight on the twine and along the top edge of the wings. With the no. 8 shader and White Wash paint, float some color to brighten the wings, more on the top of the wings. Keep the strokes choppy so it looks a little metallic in appearance.

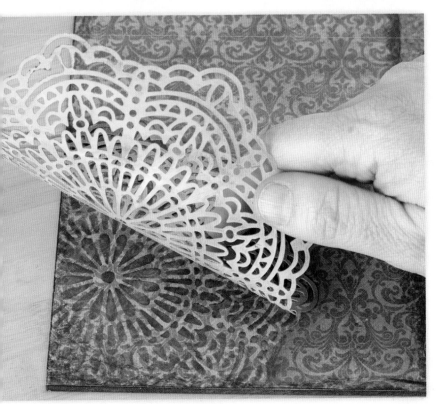

6 Add Stenciling and Collage Elements, Then Seal

Dampen your DM stippler brush, blot it dry, then load only half of the brush with Charcoal Grey paint. Pounce the brush on palette paper to remove excess paint. With your stencil in the lower left corner of the Masonite and the paint-filled side of the brush toward the stencil, stipple up around the outer edge of the stencil. When the stencil is lifted, this will give a soft shadow that fades into the background.

Now load the brush completely with Charcoal Grey, pounce away the excess paint and apply the paint to all the inside details of the stencil. If you get too heavy with the color, use a damp paper towel and blot off color.

Arrange ephemera to the piece until you are happy. Once you decide on their placement, see if they command your attention instead of the butterfly. If they do, it is probably because they are brighter white. Use watered-down Charcoal Grey paint and lightly brush over the ephemera. Let the pieces dry, then adhere them to the piece with matte medium.

Seashell

This exercise was created as a warm-up to get my day started. I collect dictionaries, so having one with the right size, texture and age was not a problem, and I do not feel bad ripping them up to use in my art—I am giving them another life by repurposing them. I will mount a lot of pages to canvases at one time, then let my mood discover the word I want to focus on. It is quick and easy, and I try not to let it take more than thirty minutes to finish. A great way to start an artful day!

Materials

8" × 10" (20cm × 25cm) canvas panel

brushes: 1-inch (25mm) wash, no.16 shader

DecoArt acrylic paint in Warm Neutral, White

dictionary page

gesso and clear gesso

kneaded eraser

Krylon Workable Fixatif

matte medium

old credit card, room key or spreader

paper towel or burlap

pencil or black transfer paper

Prismacolor Colored Pencils in Henna, Light Umber, Peach

scissors

seashell drawing template

toothbrush

 Adhere a Dictionary Page to Canvas, Paint the Background Colors Retaining the Focal Word

Find a dictionary page with the word "shell" on it. Rip it out and trim it to fit the canvas if needed. Apply matte medium to the panel, then adhere the page by smoothing out air bubbles with a spreader, working from the center out. Let the page dry. For a rougher feel, apply one coat of clear gesso on top. For a smoother feel, apply one coat of matte medium on top. Let the page dry.

Find your word on the page and any other elements you like. I usually like the page numbers to show. Apply one coat of gesso around the page leaving your chosen elements visible. Let the gesso be thicker and thinner in various areas—it will lead to a more interesting page.

Using the no.16 brush and watery Warm Neutral, apply some color on the page. Press a paper towel or piece of burlap into the paint in some areas to create texture. When the paint is dry, transfer the seashell drawing template with a pencil or transfer paper.

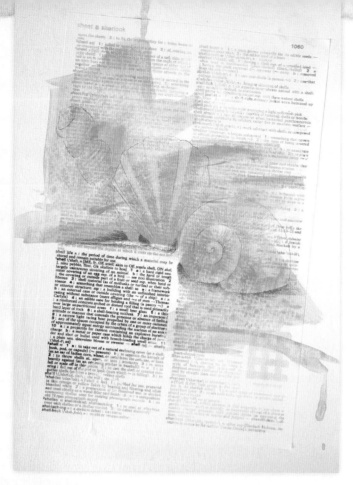

2 Add Shells with Colored Pencils

Using the templates, draw the shells on the page. Color the shells with Peach shading. Shade sand around the shell bottoms with Light Umber. With a sharp Peach pencil, create the shell striations, making sure to curve the strokes to match the shell growth.

Seashell 1 (the back shell): Darken with Henna along the bottom right-hand side of each section of the shell. Then, pull fine lines from the dark side out to the left to create striations.

Seashell 3 (the front shell): Deepen the shading along the center spiral, working outward using Henna. Again, pull fine curved lines out of the shading going along the direction of the shell.

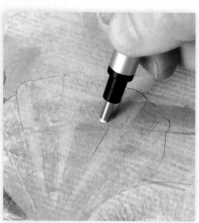

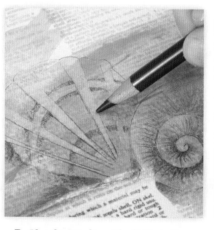

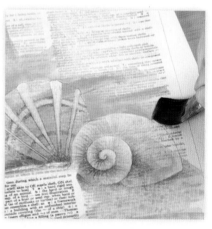

3 Remove Some Shell Guidelines

Using a white eraser, remove the color along the top curved line (the line marked X on the template).

4 Shade Darker Shell Details

Seashell 2 (the center shell): Under the top curved line that you just erased, shade with tiny vertical strokes of Henna. Do the same thing above the top curved line as well. Apply the second curved line with vertical strokes of Henna.

Pull vertical lines of Henna from the bottom center of the shell toward the top. The lines should fade as they get closer to the top. Shade the bottom of the shell with Henna to hide where the vertical lines started.

5 Paint Around the Shells to Highlight

Using Warm Neutral paint, define the top edges of each shell. Add White paint highlights using a no. 16 shading brush or a liner brush to the white areas of each shell.

Sign up for our inspiring and free newsletter at CreateMixedMedia.com.

Garden Creatures

I found a book of poetry at a library sale, and it has been a wonderful source of inspiration for my art. Select a poem to rip out or copy and let your creative muse take over. I picked this one so I could include this charming little bunny from the garden.

Materials

11" × 6½" (28cm × 17cm) water-color paper

bunny drawing template

brushes: 1-inch (25mm) wash, no.1 liner

container of water

DecoArt acrylic paints in Asphaltum, Espresso, Flesh Tone, Gingerbread, White Wash

gesso

Krylon Workable Fixatif

large bubble wrap

makeup sponge

matte medium

old credit card, room key or spreader

paper towel

poetry page

Prismacolor Colored Pencils in Black, Cream, Dark Brown, Peach, Peach Beige, Sepia, White

StencilGirl Products #SO67 stencil

stylus

white transfer paper

 Paint the Background Colors and Add Texture

Find a poetry page that inspires you and set it aside. Pour gesso onto the watercolor paper and smooth it out using a spreader. Let the gesso dry. Dampen the page with water, then apply Gingerbread paint to the left and a bit on the right, Espresso at the top and left and Asphaltum to the lower right. While the paint is wet, finger splash water over the piece. Let the water sit for about one minute, then blot it with a paper towel. Press bubble wrap into the wet paint above where the rabbit will go and allow it to dry.

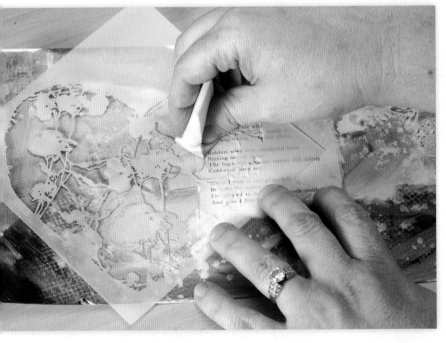

 Adhere the Poem and Stencil

Glue down the poem using matte medium. Allow the glue to dry, then layer matte medium over top. Dry. Blend the poem page into the piece by blending matching paint colors onto the poem piece. I pressed in bubble wrap because of where mine was placed. Add additional Asphaltum where your bunny is going to go, then blot the edges with a paper towel to blend.

With a stencil and makeup sponge, apply Flesh Tone and then Gingerbread to the left of the poem. Remove the stencil, then apply scratch lines with a stylus or fingernail. Let the paint dry.

3 Stencil More with a Colored Pencil

Put the stencil back down in the same spot and use a sharpened Dark Brown colored pencil to outline some areas of the stencil.

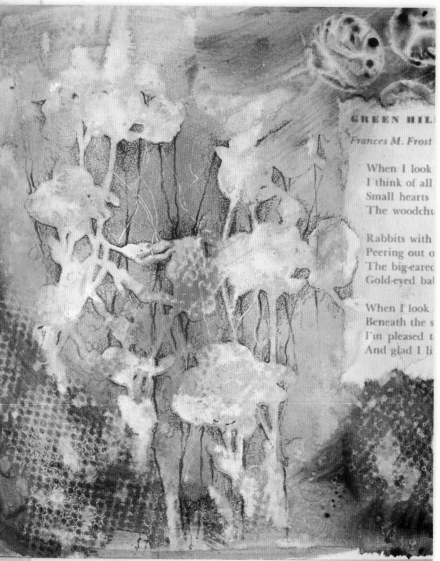

4 Remove the Stencil and Add Marks

Remove the stencil to reveal the colored pencil marks. Next to each outline, soften the line by doing circular values away from it. Add some Dark Brown lines to look like your scratched stylus lines. Continue these to the bottom of the piece in one area as if the marks were growing.

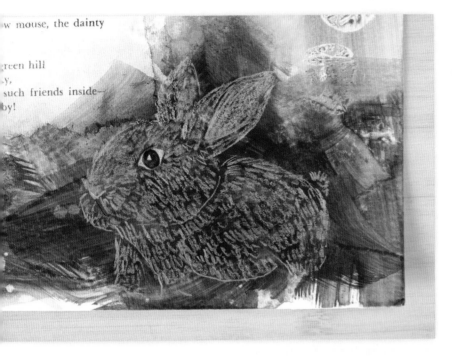

5 Draw the Bunny and Add the First Layer of Colored Pencil

Using white transfer paper, transfer the bunny using the template. You'll use colored pencils to render the bunny.

With White, fill in the three areas of the eye. The pupil is colored with Sepia, then Black. Color the nostril and mouth lines with Sepia then Black.

Use Peach to color the inner ear and nose, then use White to highlight.

Fill in the bunny's fur in the direction it grows with strokes of Peach Beige, Peach, Cream then White.

6 Add Details with Colored Pencil and Paint

Shade the bunny fur with Dark Brown then Sepia. I went outside the bunny shape to add darker shadows with Dark Brown and Sepia depending on the color around it.

With a very sharp White, add whiskers to both sides of the nose and a few eyebrow hairs. With a sharp Dark Brown, line right under those lines to help define them. With White Wash paint and the no. 1 liner, apply some brightness to the eye, whiskers and on the head. You don't want it too white, just a bit brighter than the pencil.

Seal the piece with fixative.

Materials

2–3 scrapbook papers

alphabet stamp set

Archival Ink Pad in Coffee

Artistcellar water series 6"× 6" (15cm × 15cm) stencils

brushes: 1-inch (25mm) wash, no. 1 liner, no. 8 shader, ½-inch (13mm) DM stippler

composition notebook

container of water

DecoArt acrylic paints in Charcoal Grey, Colonial Green, Flesh Tone, Mink Tan, Sea Glass, White Wash

gesso

Krylon Workable Fixatif

makeup sponge

matte medium

old credit card, room key or spreader

palette paper

paper towel

Prismacolor Colored Pencils in French Grey 90%, Jade Green, Sandbar Brown, Sap Green Light, Slate Grey

sandpaper

scissors

sea dragon template

stylus

Super Chacopaper

texture items: bubble wrap, burlap, corrugated cardboard, plastic doily, spiral paper edging

Demonstration

Mystical Sea Dragon

I just finished doing a steampunked rendition of this fantastic creature and knew he would look great on a journal cover. So, I picked a color combination of Flesh, Brown and Aqua and started gathering papers that I thought would work nicely for the subject matter. I wanted him to appear printed on the paper, so I made him blend in with my main paper piece. Paint, paper and a few added textures made this common composition book a spectacular piece of art full of mystical appeal!

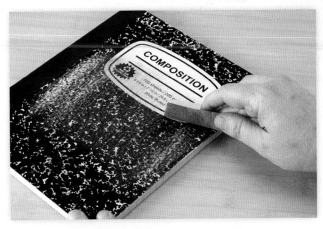

1 Sand Covers and Apply a Coat of Gesso

Sand the covers of the composition book lightly, going in one direction. Wipe away the dust with a damp paper towel. Apply one coat of gesso over the covers and spine tape. Let the gesso dry. You can put another coat of gesso over the "Composition" label unless you are going to place your paper there.

2 Paint Background Colors and Add Texture

Paint the front cover with Mink Tan and Colonial Green. While the paint is wet, press in bubble wrap, then corrugated cardboard in a couple of places to create texture. Finger spritz water over the paint, let it sit a minute, then blot it with a paper towel.

Paint the back cover with Mink Tan, Colonial Green and Sea Glass, blending the colors together softly with a wash brush. While the paint is wet, press in bubble wrap, corrugated cardboard and burlap, then finger spritz water and blot.

The tape along the spine is painted with Sea Glass and Colonial Green on one side and Mink Tan on the other. Press in bubble wrap and allow it to dry.

The covers will curl up when the paint is wet but should lie back down when dry.

Make It Easier!

Make things easy on yourself by working one cover at a time.

3 Glue on Scrapbook Papers

Tear and cut the scrapbook papers to find a design you are happy with. I started with the large piece for the sea dragon, which I cut to 4½" × 5½" (11cm × 14cm) and then moved to the smaller pieces. I like to have some edges cut and some torn to make a more interesting look. Adhere the papers to the covers with matte medium and smooth from the center outward with a spreader. Cover all the paper with matte medium, except the piece saved for the sea dragon. Wipe away excess medium that has seeped from under the papers with a damp paper towel.

jour·nal ‖ noun
1. a newspaper or magazine that deals with a particular subject or professional activity.
"medical journals"
synonyms: periodical, magazine, gazette, digest, review, newsletter, bulletin
2. a daily record of news and events of a personal nature; a diary.
synonyms: diary, daily record, daybook, log, logbook, chronicle

Visit CreateMixedMedia.com/colored-pencil-collage for bonus materials.

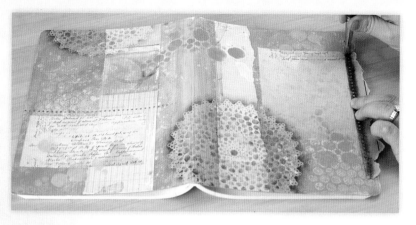

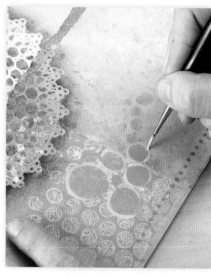

4 Add a Variety of Stenciling

With the plastic doily, Charcoal Grey paint and the DM stippler, apply paint to the outside edge of the stencil. Dampen the brush, blot it dry, then load only half of the brush with paint. Pounce it on palette paper to remove excess paint. With the paint half of the brush toward the stencil, begin stippling up and down all the way around the stencil's edge. When the stencil is lifted, this will give a soft shadow that fades into the background.

Now load the brush completely, pounce away the excess and stencil the inside details of the stencil. If you get too heavy with the color, use a damp paper towel and blot it off. The stencil on the front cover should be darker than the one on the back cover. You can use Mink Tan for the back if you want some variety.

With notebook paper edging as my stencil, I used Charcoal Grey and the stippler brush to make the dot pattern on the front and back covers.

5 Outline Select Stencil Marks with Paint

Using the bubble stencils from the water series, use a makeup sponge to apply Mink Tan, Flesh Tone and Sea Glass bubbles randomly. When the paint is dry, outline the bubbles with a no. 1 liner and either Flesh Tone or Sea Glass.

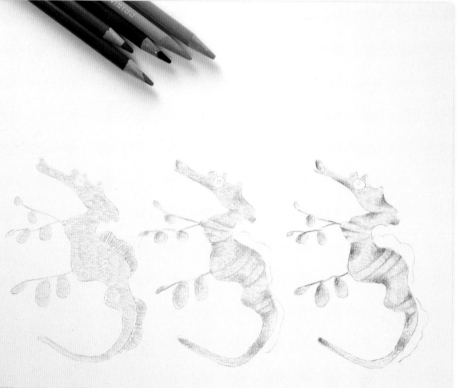

6 Draw the Sea Dragon on Scrapbook Paper

Transfer the sea dragon template to the scrapbook paper piece using a stylus and Super Chacopaper. The wonderful quality about this paper is that with a barely dampened brush you can remove the transfer yet leave the colored pencil in place.

7 Color the Sea Dragon and Shade the Body

Fill the dragon and appendages with Jade Green colored pencil. The shading on the rest of the dragon is done with Slate Grey. Make sure to start at the edge with 30% pressure, then fade into the middle. The lines that create the body segments are made with Slate Grey with a touch of shading to the right of each line. Deepen the shading with French Grey 90%. Color the clear fin sections with lines of Sap Green Light.

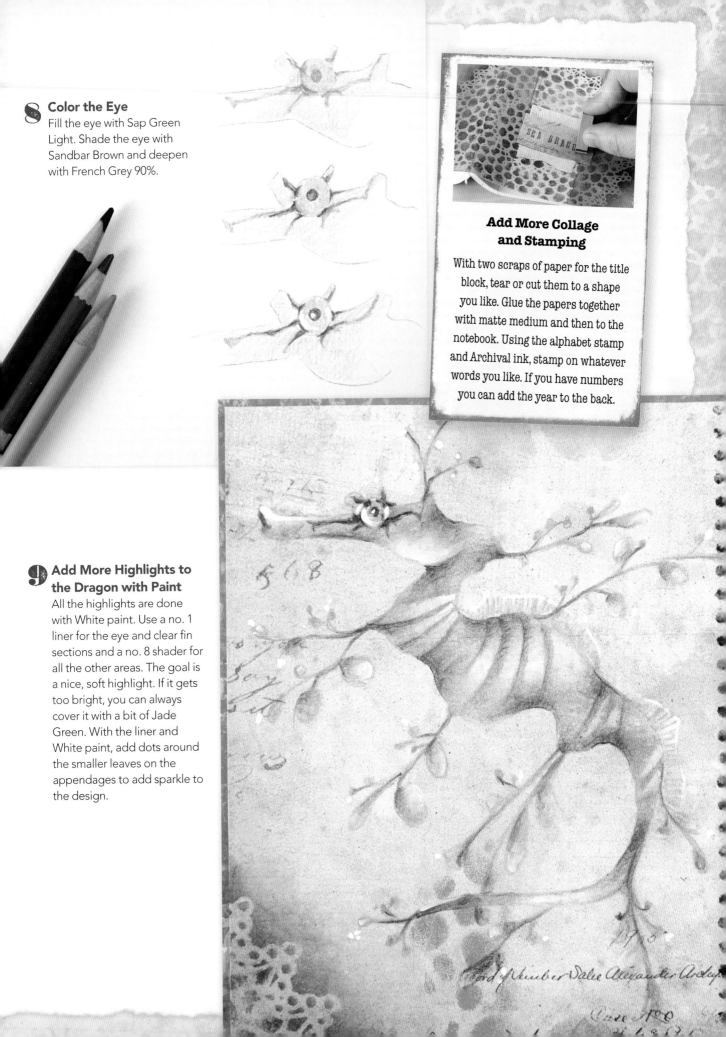

8 Color the Eye

Fill the eye with Sap Green Light. Shade the eye with Sandbar Brown and deepen with French Grey 90%.

Add More Collage and Stamping

With two scraps of paper for the title block, tear or cut them to a shape you like. Glue the papers together with matte medium and then to the notebook. Using the alphabet stamp and Archival ink, stamp on whatever words you like. If you have numbers you can add the year to the back.

9 Add More Highlights to the Dragon with Paint

All the highlights are done with White paint. Use a no. 1 liner for the eye and clear fin sections and a no. 8 shader for all the other areas. The goal is a nice, soft highlight. If it gets too bright, you can always cover it with a bit of Jade Green. With the liner and White paint, add dots around the smaller leaves on the appendages to add sparkle to the design.

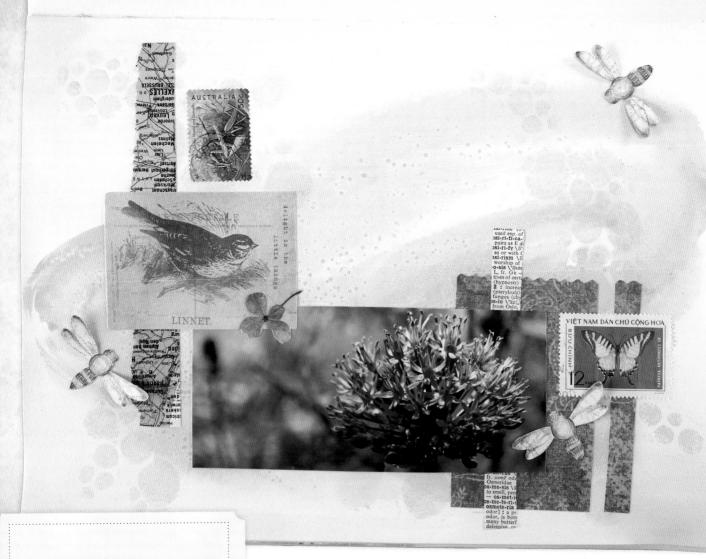

Demonstration

Journal Pages

Journal pages are a fun way to loosen up, experiment with technique or try something new. I love to combine photos, magazine clippings, found ephemera and simple color to mine. I find that one background color usually satisfies my creative need because I know I will be adding elements to enhance the overall feeling. Rubber stamps, ephemera, texture tools, photos—there is nothing that can't go into my journals. Just have fun—they aren't meant to be masterpieces, just everyday art meanderings.

Materials

art journal

bee template

black transfer paper

brushes: bristle

container of water

DecoArt acrylic paint in Lilac

ephemera including a photograph and atlas page

gesso

matte medium

Prismacolor Colored Pencils in Black Cherry, Sandbar Brown, Yellow Ochre

stencils

table salt

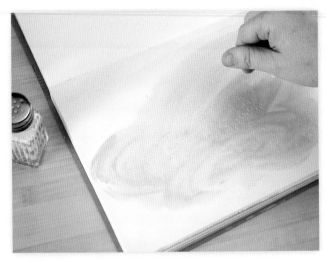

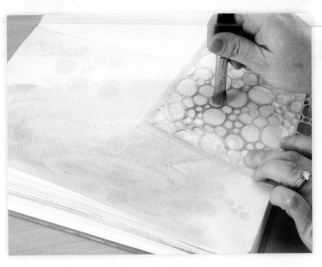

1 Gesso a Page, Add Paint and Salt

Gesso a page in your journal. Spritz the page with water, then paint a layer of Lilac paint using a circular motion. Sprinkle some table salt on the wet paint. Allow the paint to dry, then brush off the salt.

2 Stencil Texture Into the Color

Choose a stencil and add some stenciling using the same Lilac paint. Apply the stenciling with a slightly damp stiff bristle brush and a pouncing motion.

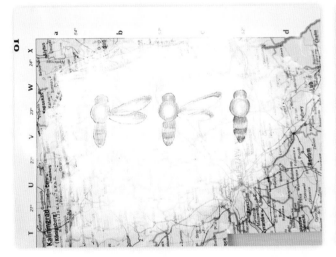

3 Draw and Color Bees on a Gessoed Atlas Page

Gesso a page from an atlas and trace three bees using black transfer paper. Leaving some white space on the body, color in the rest of the bee (the head, body and tail) with Yellow Ochre colored pencil. Shade all body parts and define the tail stripes with Sandbar Brown. Deepen the shading with Black Cherry.

Shade the wings with Sandbar Brown and deepen with Black Cherry.

4 Arrange and Adhere the Collage Elements Including the Bees

Arrange ephemera on your journal page until you're satisfied, varying the sizes, shapes and colors. Using matte medium, glue down the bottom elements first, then the top layer. I chose to use mostly square elements to contrast with the circular painting and stenciling.

Fold up the wings of the bees at the edge of the body and glue only the body to the journal page using matte medium.

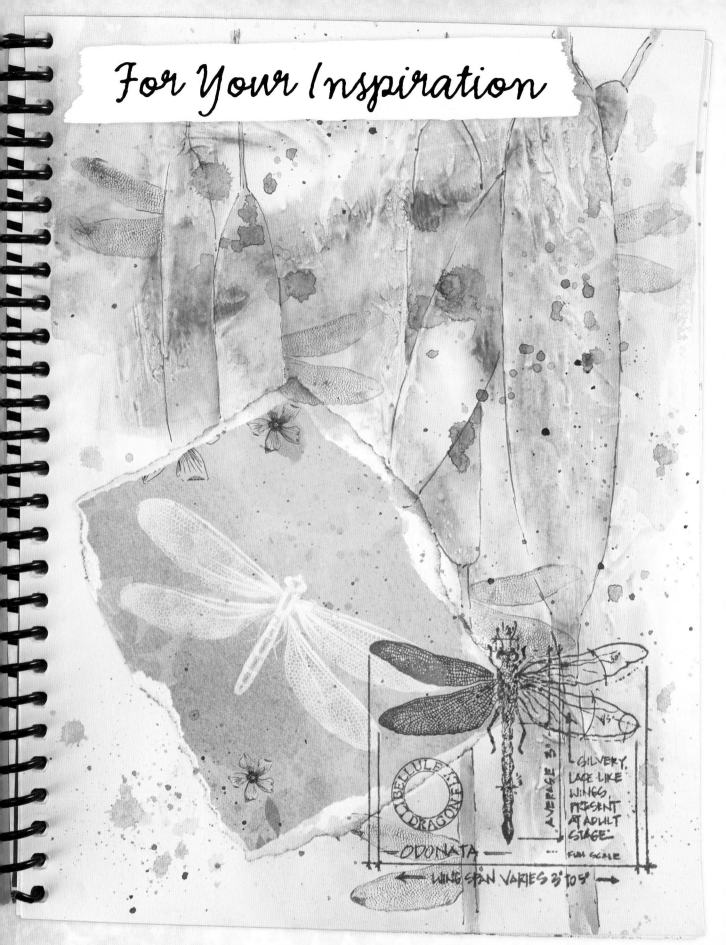

For Your Inspiration

This page uses rubber stamps, scrapbook paper, plastic wrap and inked details.

Sign up for our inspiring and free newsletter at CreateMixedMedia.com.

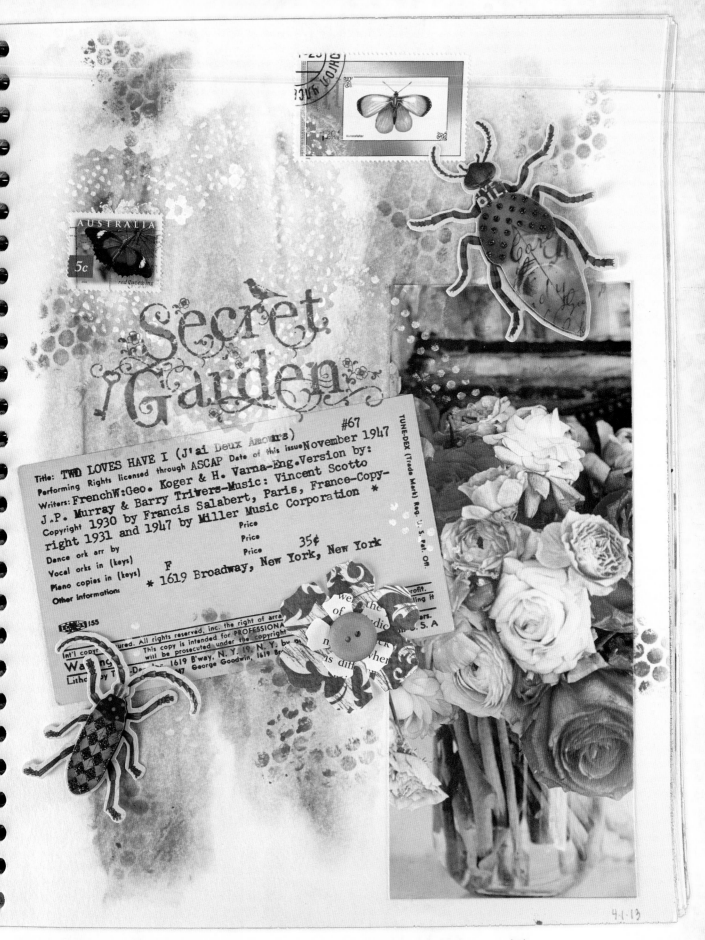

This page uses stamps (rubber and postal), magazine clippings, scrapbook die-cuts and a button.

7. Embellishments

Embellishments are touches that I use to make a piece of art my own. They are the things I love to collect, look at and discover. They come from anywhere: the outdoors, the hardware store, an antique shop, the mail, online. The possibilities are endless. I have my favorites—cancelled postage stamps, headlines, ticket stubs and ledger paper—but this journey is about you and what you like. Start by looking around at what you own. Is there a common color, theme or subject matter that means something to you? This is very personal, and when you can put a piece of something you love into your art, it takes on a different meaning.

In this chapter we are going to explore our photos, our ephemera collections, some found objects and things that make you smile. Adding these to your collage and making them stand out are great ways to express who you are and what you like. So shop in your own house and look for those pieces that put a little smirk on your face, hold a special moment in time and can add meaning to your art. It's really that easy to begin.

em·bel·lish·ment ‖ noun
1. a decorative detail or feature added to something to make it more attractive.
"architectural embellishments"
synonyms: decoration, ornamentation, adornment
2. a detail, especially one that is not true, added to a statement or story to make it more interesting or entertaining.
synonyms: elaboration, addition, exaggeration
3. the action of adding details or features.

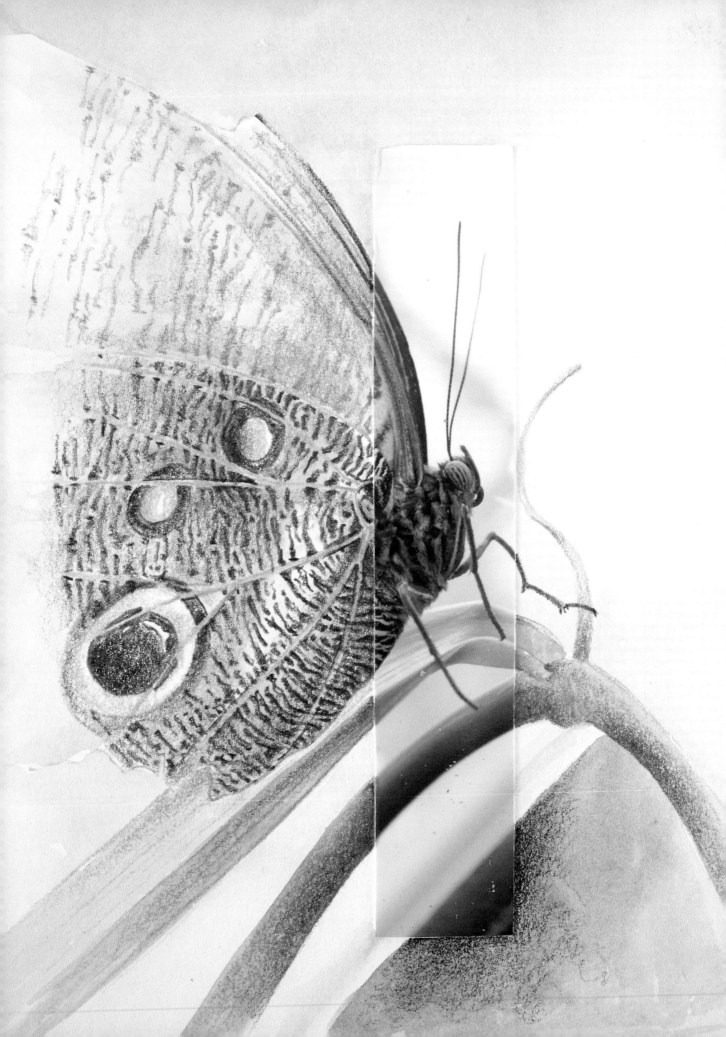

A Tattered Specimen

I took this photo at a butterfly garden and loved it because of the soft colors and wonderful moth details it showed. The wings are tattered, probably from hundreds of children reaching out to touch the delicate insect, but he stood by the window letting me get shot after shot, and for that he will always be fondly remembered. I have started with a 1" (3cm) wide strip of a detailed area of the photo I didn't want to recreate. From there I reassembled the image with colored pencil and watercolor one step at a time, making this an unusual piece of art.

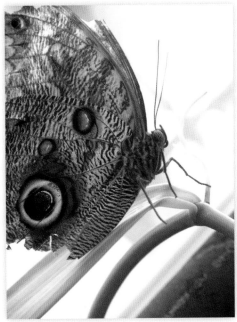

Reference Photo

Materials

4" × 6" (10cm × 15cm) photo of your choice

6" × 8" (15cm × 20cm) Strathmore mixed-media paper

brushes: 1-inch (3cm) wash, no. 8 shader, no. 6 round

Krylon Workable Fixatif

matte medium

paper towel

pencil

Prismacolor Colored Pencils in Celadon Green, French Grey 90%, Goldenrod, Kelp Green, Limepeel, Sandbar Brown, Yellow Ochre

ruler

Sakura Koi watercolor set

scissors

Super Chacopaper

tracing paper

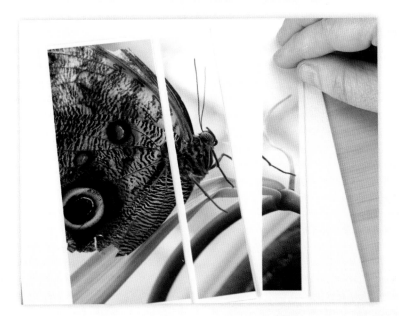

1 Select a Photo and Trace the Important Elements
Trace the important details of the photo onto tracing paper. Find the detailed area you want to remain as the photo and mark it as a 1" (3cm) strip with pencil. Cut out the strip.

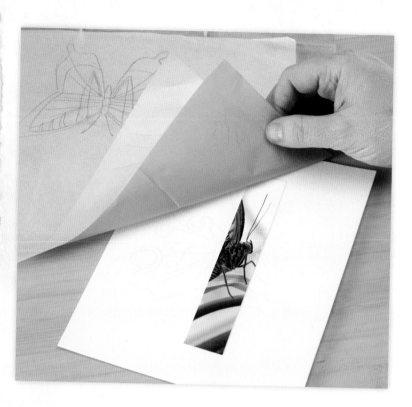

2 Adhere the Photo Slice and Add Traced Elements Around the Photo

Apply a scant amount of matte medium on the back of the strip and press the strip onto the paper with a paper towel to avoid fingerprints. Let this dry. Transfer the details of the remainder of the image with Super Chacopaper to complete the photo.

To not lose the design, we need to draw in a few lines with colored pencil so we can find them once we watercolor (remember, the Superchaco lines are water-soluble). Outline the wing circles and put in the vein lines with Goldenrod using a thick and thin pressure line. On the top wing there is a double line of Goldenrod and a shadow line of French Grey 90%. The leg and wing edges are done with Sandbar Brown deepened with French Grey 90%. Color the leaves using Limepeel. Mark the plant tendril with Yellow Ochre.

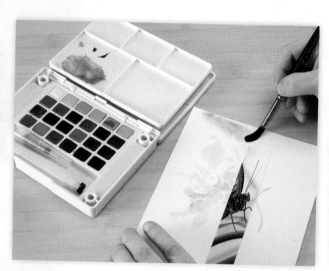

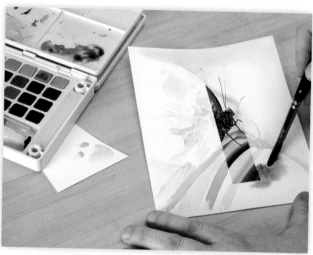

3 Add Light Watercolor Paint to the Background

Using the photo as your color guide, recreate the photo to the best of your ability. I used watercolors to apply the main colors and the details were all done with colored pencils. A key to using watercolors is to remember that the color directly across from it on the color wheel will dull and gray the intensity of it. So red and green dull each other, as do blue with orange and violet with yellow.

4 Add Darker Watercolors

When I mix a color that I think is close, I test it on a piece of copy paper, then adjust the color as needed. Keep a large damp brush handy to soften the edges of your paint lines. Work with whatever brush will fit the area and paint just one section at a time.

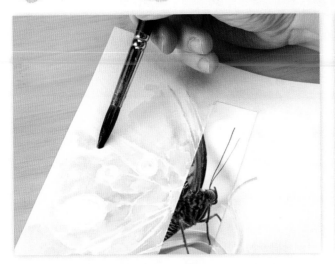

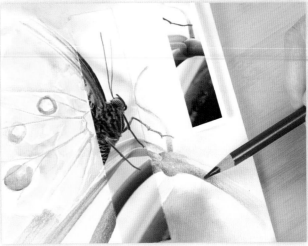

5 Color the Wings with Watercolor and Allow to Dry

Color the wings with Yellow Ochre, a brownish gray, and the sky color to give them interest. Let the watercolor dry.

6 Add the Lightest Colored Pencil Values

The details are now all colored pencil. Color the tendril with Yellow Ochre shaded with Sandbar Brown. The insect foot is Sandbar Brown deepened with French Grey 90%.

The lightest values of the greenery are Celadon Green shaded with Limepeel. The medium and dark values are filled with Limepeel shaded with Kelp Green. Shade the bottom edge with French Grey 90%, letting it fade away as it goes from the photo.

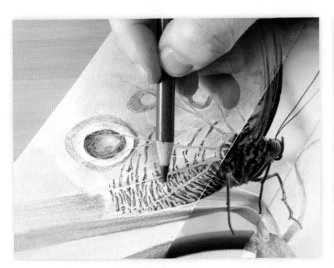

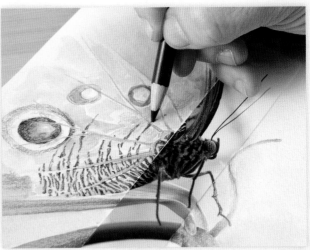

7 Add Darker Colored Pencil Values Including Stripes and Eye Spots

Starting at the bottom of the wing, make a zebra stripe pattern with French Grey 90%. Color the bottom two sections, then shade the whole area with Sandbar Brown to make the wings appear in shadow. Outline around the vein lines with Sandbar Brown or French Grey 90% depending on the value around them.

Continue the zebra stripes, making sure to change the direction within each vein section. This alone will make the moth's wings more believable. Color the top two wing sections and the zebra stripes with Sandbar Brown.

8 Color the Darkest Values

Color the eye spot centers using Yellow Ochre, making sure to leave a bit of white space in them for a highlight. Shade the eye spots with Goldenrod. Fill the dark circles with Sandbar Brown. Fill them again with French Grey 90%. Outline around the vein lines to keep them nice and sharp.

Add Yellow Ochre and Goldenrod values to the wing sections if needed to pull more color throughout them. From the eye spots to the left, shade zebra sections with Sandbar Brown to dull them.

Spray with fixative to seal.

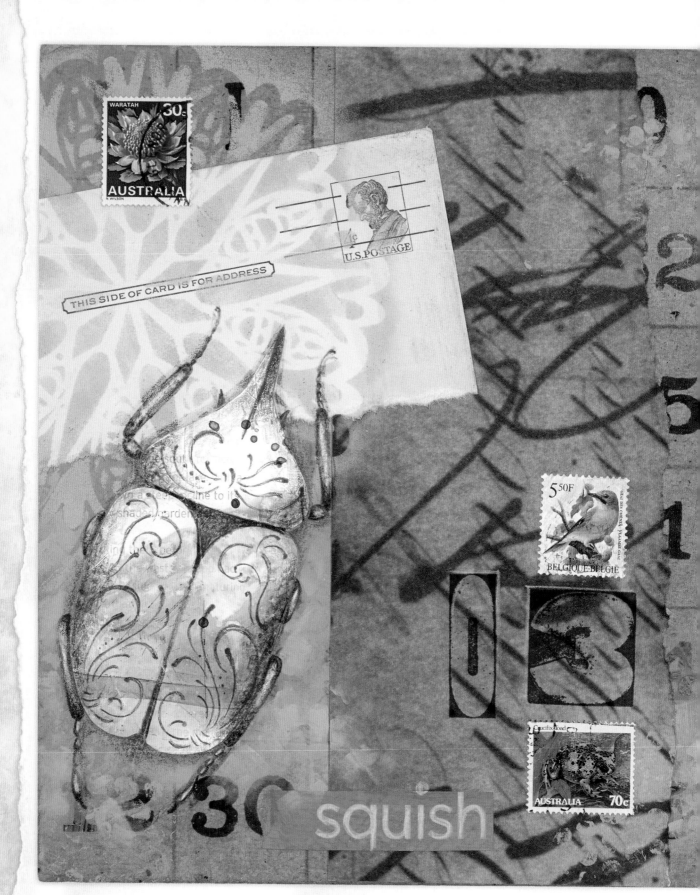

Squish, Really?

I love and collect game pieces and came across these giant handmade bingo cards. They are just chipboard but I know the memories of many nights of bingo are tied into them. I also wanted to add a headline, so when I saw "squish" I knew it would be perfect. Instead of making the beetle realistic, I took artistic license and put elegant strokework on his shell. Imagine finding one of these in your neighborhood!

Materials

- 1-inch (25mm) wash brush
- 7½" × 9" (19cm × 23cm) bingo card
- Archival Ink Pad in Coffee
- beetle template
- black transfer paper
- bubble wrap
- clear gesso
- container of water
- DecoArt acrylic paint in Base Flesh, Fawn, Sea Glass, Soft Black, Toffee
- gesso
- Golden Regular Gel
- Krylon Workable Fixatif
- makeup sponge
- number stamps
- old credit card, room key or spreader
- palette knife
- paper ephemera: book page, postcard, cancelled postage stamps, headline, scrapbook paper
- paper towel
- Prismacolor Colored Pencils in Dahlia Purple, French Grey 70%, French Grey 90%, Sandbar Brown, Slate Grey, White
- scissors
- stencils: Crafter's Workshop Mini Bug Doily, Rebecca Baer Scrollwork Stencil
- table salt

game ‖ noun
1. a form of play or sport, especially a competitive one played according to rules and decided by skill, strength, or luck.
2. a type of activity or business, especially when regarded as a game. "this was a game of shuttle diplomacy at which I had become adept"
‖ adjective
1. eager and willing to do something new or challenging.
‖ verb
1. play games of chance for money.
2. manipulate (a situation), typically in a way that is unfair or unscrupulous.

1 **Cover a Bingo Card with Clear Gesso and Add Background Colors**

Apply clear gesso to a bingo card using a spreader. While the gesso is drying, select your headline phrase ephemera and paint a wash of Fawn over it to tone it down. Apply Fawn, Toffee and Base Flesh in a diagonal pattern on the bottom right corner of the bingo card. Keep the color looking stroked on to add texture to the background for the beetle. While the paint is wet, press in bubble wrap.

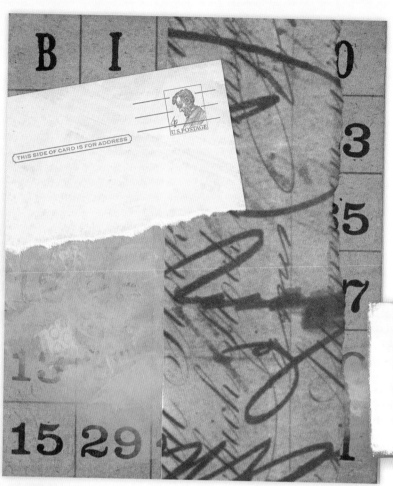

2 Adhere Paper Collage Elements

Rip scrapbook paper and adhere it to the bingo card using regular gel. Layer a postcard over the scrapbook paper. If the postcard color is too light, apply clear gesso over the top, then add a watery paint mixture of Toffee plus Fawn. After you apply the paint, press a paper towel on it to pick up some texture.

Make Use of Telephone Books

Use an old telephone book as a space to add glue to loose papers to prevent excess glue from getting on your workspace or art.

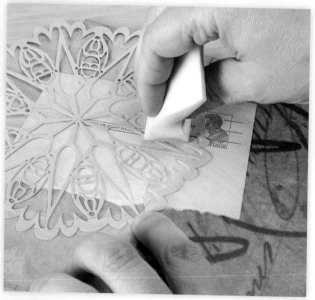

3 Add Stenciling with Matching Paint

Apply bug stenciling to the upper left corner using Sea Glass and a makeup sponge.

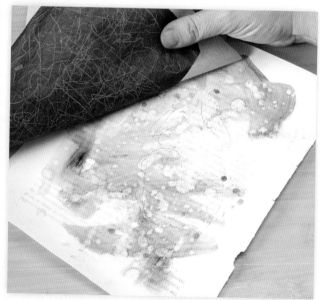

4 Create Texture on a Gessoed Book Page, Trace a Beetle Onto the Page

Apply one coat of gesso to a book page using a spreader. Let the gesso dry. Dampen the page, then apply watery Soft Black paint randomly on the page creating varying values. Splash the paint with water or sprinkle with table salt to add texture. When the paint is dry, trace a beetle on the page using transfer paper.

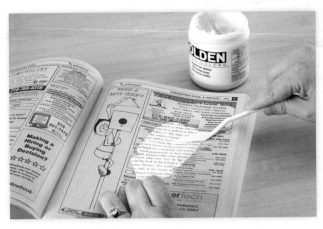

5 Cut out the Beetle and Adhere it to the Bingo Card

Cut out the beetle shape and adhere it to the bingo card with regular gel and a palette knife.

6 Add Colored Pencil Stencil Designs to the Beetle

Create the details of the beetle using colored pencils.

Highlight the legs and arms with White. Outline and fill the rest of the arms and legs with French Grey 70%. Lightly go over the white areas to tone them if needed. Shade the arms and legs with French Grey 90%.

The neck and wing separation plus the pinchers are done with French Grey 70% and then shaded with French Grey 90%. Shade the beetle edges with Slate Grey.

Apply the scrollwork stencil design with a very sharp Dahlia Purple.

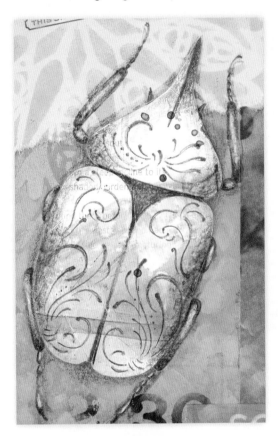

7 Embellish the Beetle with Colored Pencil

Strengthen the design by adding soft dots at the ends of the strokes or thickening the lines in a couple of areas.

Soften the beetle edges by shading lightly with French Grey 90%. Around the beetle use Sandbar Brown to make shadows, then deepen with French Grey 70% if needed.

8 Adhere Additional Collage Elements to the Card

In the lower left corner of the bingo card, stamp numbers onto the scrapbook paper. Loosely paint some Toffee below the beetle to pull some color, breaking the hard vertical line of the paper. Gently rub some Base Flesh paint on small bubble wrap, then press the wrap onto the bingo board.

Adhere the headline and stamps with regular gel. With a White pencil, fill the word in again to brighten it a touch. Shade the stamps or postcard, if needed, with Sandbar Brown or a wash of Fawn to tone them down.

Seal the piece with fixative.

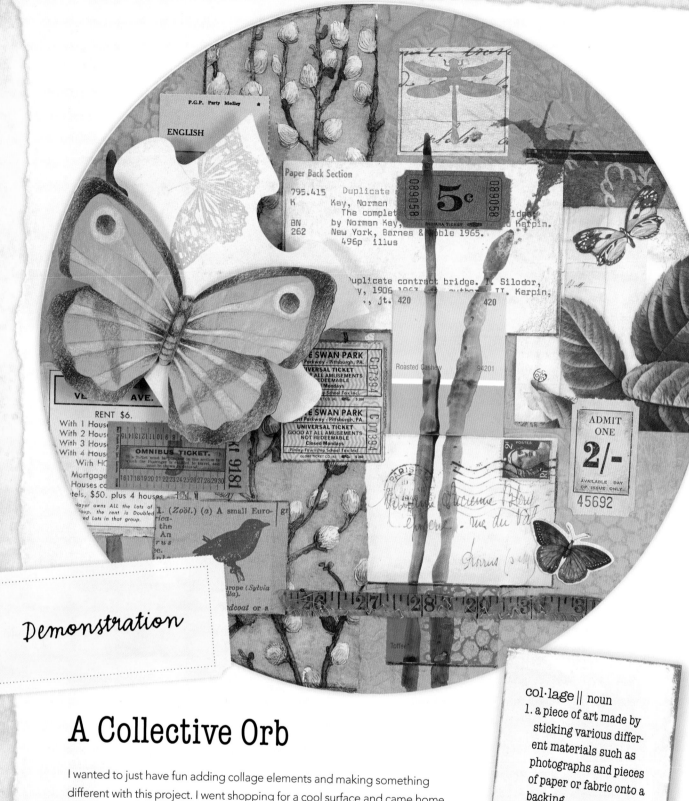

Demonstration

A Collective Orb

I wanted to just have fun adding collage elements and making something different with this project. I went shopping for a cool surface and came home with a cardboard cake board. Kind of fun, right? It is large, giving me lots of room for the paper ephemera I love, yet there is still space for a large butterfly perched on a fun puzzle piece. This is your place to shine, so bring out everything you like. Reread the design section for hints, and go to town creating a one of a kind collective treasure.

col·lage || noun
1. a piece of art made by sticking various different materials such as photographs and pieces of paper or fabric onto a backing.
"the art of making collages"
2. a combination or collection of various things.

Materials

12" (30cm) cake board

3 wooden spacers or scrap cardboard

brushes: 1-inch (25mm) wash, ½-inch (13mm) DM stippler

butterfly template

chipboard butterfly tags (set of 3)

clear gesso

container of water

craft knife

DecoArt acrylic paint in Asphaltum, Camel, Colonial Green, Desert Sand, Terra Cotta

DecoArt Faux Glazing Medium

Golden Regular Gel

Krylon Workable Fixatif

matte medium

palette knife

paper ephemera: tickets, tags, cancelled postage

stamps, scrapbook paper, library cards, postcards, paint chip, punch remnants, anything else you collect

paper towel

pencil

plastic wrap

Prismacolor Colored Pencils in Aquamarine, Dark Umber, Kelly Green, Light Umber,

Nectar, White, Yellow Ochre

puzzle piece (kids' puzzle or scrapbook piece)

ruler

sandpaper

scissors

stencils

stylus

Super Chacopaper

1 Paint the Cake Board and Mix the Glazing Medium

Apply one coat of clear gesso to the cake board using whichever side appeals most to you. (If you use bright colors you might want to use the white side. I used the dark side to stick to a more muted palette.) Let the gesso dry. Using Camel, Colonial Green and Terra Cotta paints, create a nice blend, letting each color take about one-third of the board. Blend the Camel into the other colors to softly transition from one color to the next.

Mix the Faux Glazing Medium with Desert Sand paint in equal parts and blend well with a palette knife (Mix A). Make a large amount of this because you have to work quickly.

2 Apply the Glazing Mix and Add Texture with Plastic Wrap

Working quickly, dampen the board with water, then apply Mix A. Cover the wet board with plastic wrap and squish it together in places to create texture.

3 Repeat Until Satisfied

Lift and squish until satisfied. Allow the paint to dry.

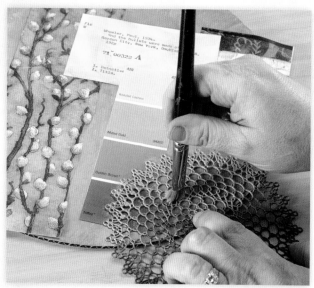

4 Adhere the First Layer of Collage Elements and Add Stenciling

Lay out the collage pieces making sure to vary sizes, shapes and colors for added interest. Once you're satisfied with the arrangement, take a photo or move the ephemera to another cake round to retain the placement. I actually marked some of the larger elements with pencil outlines. Adhere the background pieces first with regular gel.

Once you have some of the larger elements down, stencil with Mix A to add a slight pattern. If you have an element that is too bright, tone it down with watery Mix A.

Once the stenciling is dry, adhere the next level of items.

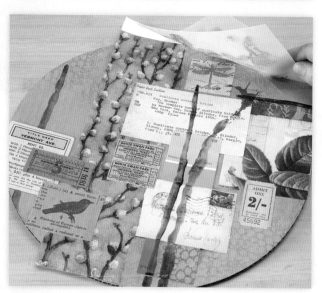

5 Adhere Additional Collage Elements, Add a Paint Drip and More Stenciling

Add a long drip of Asphaltum running up the collage. You can make these look like branches by moving your brush in a halting motion, stopping every inch (3cm) or so. Add a splat of paint at the top of one line using a stencil.

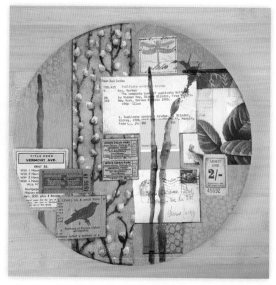

6 Shade the Collage Elements to Integrate

Add a touch of Sepia colored pencil shading to each collage element to bring them all together. Some pieces have a strong line; others have some light shading.

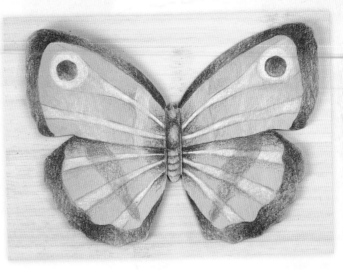

7 Draw and Color the Butterfly Shapes

On the butterfly, apply Mix A to both sides and allow to dry. Trace the butterfly template using Super Chacopaper. The details are colored pencil. The eye spot's outer ring is White and the inner is Light Umber. Shade the inner circle with Dark Umber toward the tip near the top wing.

8 Color the Top of the Butterfly Wings

Color around the eyespots with Nectar values getting light toward the center of the color block. From the bottom of that area, color White and then Yellow Ochre getting lighter toward the top. Where the colors meet there should be a nice value of both colors.

9 Color the Bottom of the Butterfly Wings

Color the bottom color block the same way with Kelly Green values at the top getting light toward the bottom, and Aquamarine getting lighter toward the top, blending in the middle.

The inner color band is White with Yellow Ochre over it.

Outline the wing edges, then fill them in with two layers of Light Umber at 30% pressure.

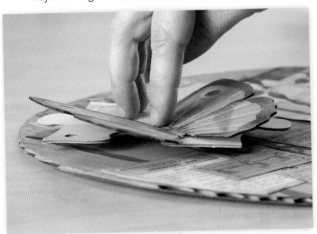

10 Deepen the Shading

Deepen the wing outlines with thick and thin lines and gradient values of Dark Umber.

11 Color the Wing Veins and the Body

Create veins in the wings with Light Umber. Fill the inside of the veins with White going over the color bands last. Wipe off the pencil tip each time to prevent color transfer. Shade under or above the veins with Light Umber. Deepen the shading near the body with Dark Umber. Separate the wings with Light Umber, then deepen them with Dark Umber.

Fill the body with Light Umber. Shade the outer edges using Dark Umber and brighten the body with White in the center.

12 Adhere the Butterfly, Fold the Wings and Seal

With a ruler and stylus, score the front and back of the butterfly along the body, then cut a shallow line on the front side with a craft knife. Using the ruler as a guide, slowly crease the wings upward.

Sand and gesso the puzzle piece, then paint it or glue paper on top of it. Glue the butterfly's body to the puzzle piece using matte medium. Only glue the body, not the wings. Adhere the puzzle piece and the butterfly to the collage board using three spacers or extra cardboard and matte medium to add dimension and make them stand out from the main collage.

Spray the piece with a fixative to seal.

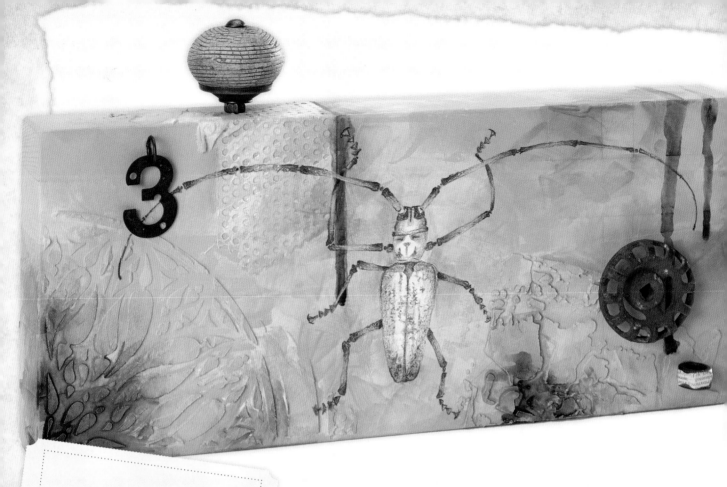

A Curious Study

I was lucky enough to go behind the scenes at the Field Museum of Natural History in Chicago and study insect specimens firsthand. The guy on this piece was from that special experience. I knew I wanted to give him a place of honor yet find most of the added items in a hardware store or my garage. The pieces are simple, yet when finished this sure makes a statement of curious, quirky goodness. Have fun with this piece and remember one man's junk is another man's treasure.

Materials

12" × 6" × 2" (30cm × 15cm × 5cm) wood block, sanded and rounded at the corners

beetle template

black transfer paper

brushes: 1-inch (25mm) wash, no. 10 round

container of water

DecoArt acrylic paint in Cool Neutral, Ice Blue, Mississippi Mud

drywall tape

Golden Light Molding paste

Krylon Workable Fixatif

masking tape 1" (3cm) wide

metal findings and cabinet knob

old credit card, room key or spreader

palette knife

paper towel

pencil

Prismacolor Colored Pencils in Dark Umber, French Grey 20%, French Grey 70%, Indigo Blue, Sandbar Brown, Slate Grey, White

ruler

stencils: Artistcellar cathedral series, StencilGirl Products Journaling Left Hand

white gesso

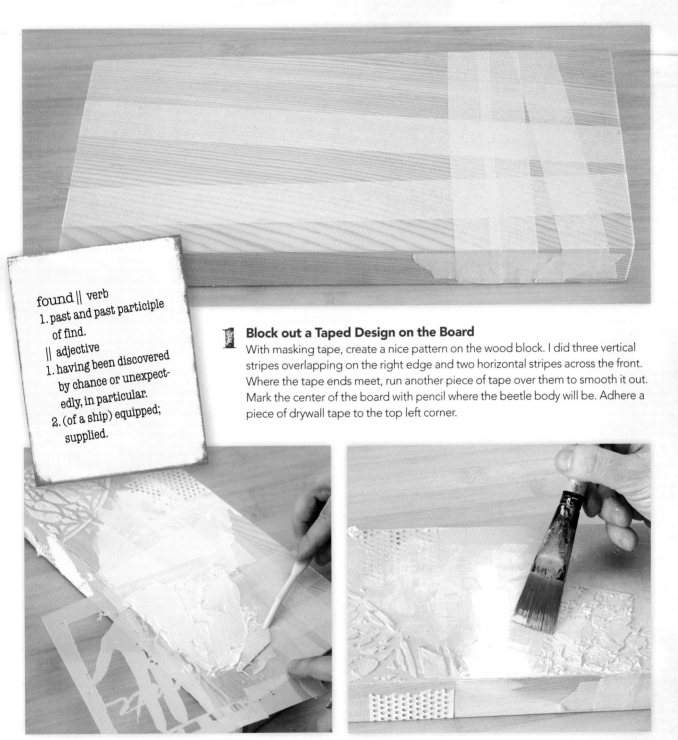

found || verb
1. past and past participle
 of find.
|| adjective
1. having been discovered
 by chance or unexpect-
 edly, in particular.
2. (of a ship) equipped;
 supplied.

1 Block out a Taped Design on the Board

With masking tape, create a nice pattern on the wood block. I did three vertical stripes overlapping on the right edge and two horizontal stripes across the front. Where the tape ends meet, run another piece of tape over them to smooth it out. Mark the center of the board with pencil where the beetle body will be. Adhere a piece of drywall tape to the top left corner.

2 Apply Gesso and Molding Paste in Select Areas

Apply a solid white layer of gesso where the beetle will go. Apply light molding paste through the stencils with a palette knife in both top corners to create an interesting area. I added a little more in a couple of areas just to give them more dimension. Carefully lift the stencil and rinse immediately. Remove any excess molding paste from the top and bottom of the board using a palette knife. This will have to dry overnight.

3 Trace on the Beetle and Apply Basecoat of Paint

With black transfer paper, lightly trace the beetle head and body on the gessoed area. Paint one layer of Cool Neutral over the entire board except where the head and body are marked. Allow the paint to dry.

Visit CreateMixedMedia.com/colored-pencil-collage for bonus materials.

4 Paint Additional Colors

As you add more paint color, work one section of the board at a time. Always begin with Cool Neutral, then add Ice Blue followed by Mississippi Mud, blending them smoothly into one another. Let the strokes show for texture. Whenever you touch into Mississippi Mud, rinse your brush and start the process again until the front and sides are colored.

5 Create Drips of Paint

Add watery drips of Mississippi Mud next to the beetle outline.

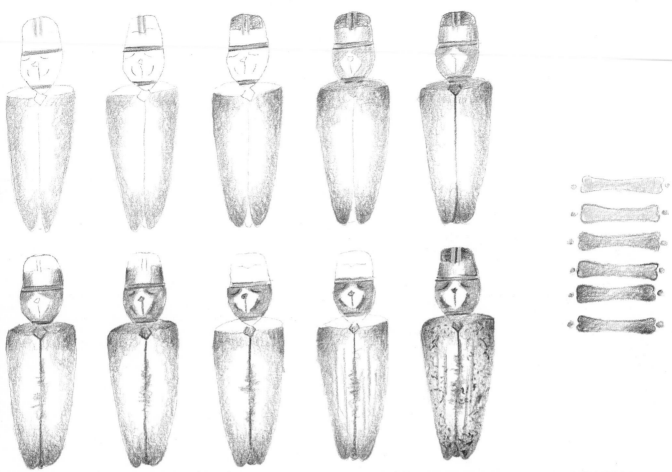

6 Draw the Beetle Body

When the paint is dry, apply the rest of the beetle pattern with black transfer paper. Create the beetle details with colored pencil.

7 Color the Antennae, Arms and Legs

The antennae, legs and arms are all done in the same manner as shown above. First, fill the section with French Grey 20%. Outline the shape and fill it with French Grey 70% going over the middle area lightly. Outline the shape again with thick and thin pressure of Dark Umber, then shade with varying values.

8 Create Joints Between the Segments

There are balls in between each joint, and these are done with French Grey 20% followed by Dark Umber. Where the arms cross the drip, highlight the segment with white (see detail, right). On the segments next to the beetle's body, add a touch of Indigo Blue in the darkest areas.

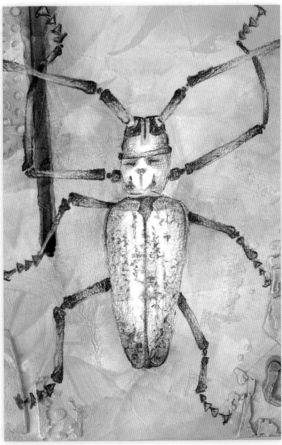

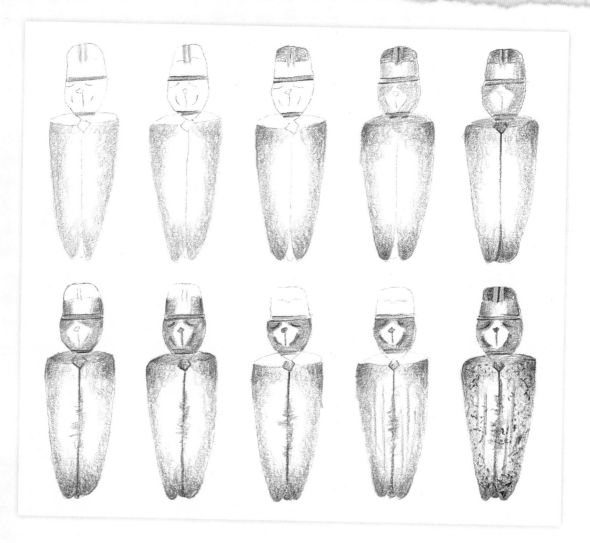

9 Create and Color the Head Sections

Color a horizontal division line in the middle of the head using Sandbar Brown, outlining above and below with Dark Umber, then a touch of Indigo Blue at the edges.

Add two stripes of French Grey 20% down the middle of the forehead, then put Slate Grey over it. Outline the top of the head and fill it with Dark Umber, then deepen with Indigo Blue.

Shade the next section of the head (still above the horizontal division line) from edges inward using Sandbar Brown, then Slate Grey. Deepen the area with Dark Umber followed by a touch of Indigo Blue.

Fill in the next area except the middle diamond with Sandbar Brown, then Slate Grey. Shade with Slate Grey, then French Grey 70%. Draw the features inside the diamond with Dark Umber. Deepen these areas with Slate Grey, then Indigo Blue. Line the diamond with Sandbar Brown, then add Dark Umber lines above and below.

10 Create and Color the Neck and Shoulders

The neck area is filled with Sandbar Brown then Slate Grey. Shade it with Dark Umber, then Indigo.

Fill the shoulders with Sandbar Brown then Slate Grey, then shade with French Grey 70%. Outline the top edge using French Grey 70% then add a touch of Indigo Blue to outline.

11 Color and Create the Wing Details

The wings are created from the outside in to create the roundness of the bug's shape. Along the edge, create color values of Sandbar Brown, getting lighter as you go into the center. Color Slate Grey over it. Notice the bottom fourth is filled in with values. Shade with French Grey 70% at the bottom and the top next to the shoulders. Touch in Indigo Blue. With Dark Umber, draw lines down from the shoulders and up from the tail with thick-thin strokes.

Make the wing seam fuzzy with Sandbar Brown then Slate Grey. Lightly touch in Indigo Blue. Add vertical lines with Sandbar Brown then Slate Grey over them. Lightly touch in more Indigo Blue.

12 Add Overall Texture

With a sharp Indigo Blue pencil, add dots for texture followed by dots of French Grey 70% all over the body and Dark Umber on the tail.

Sign up for our inspiring and free newsletter at CreateMixedMedia.com.

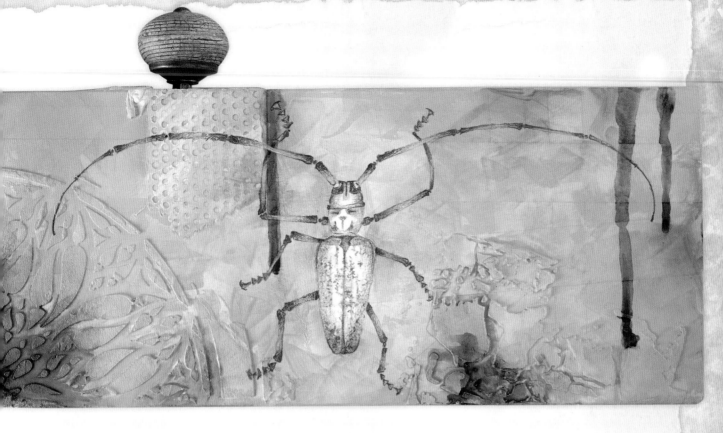

13 Shade Around the Beetle and Add Repurposed Hardware

With a paint color already on the wood, shade around the beetle as needed.

Spray the piece with fixative to seal it.

Embellish the board with found and repurposed hardware.

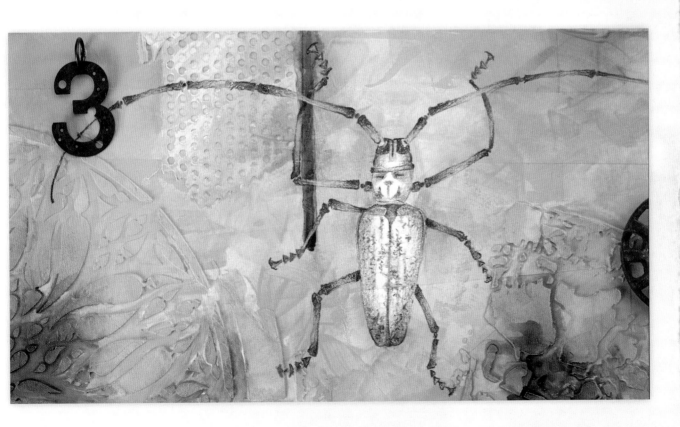

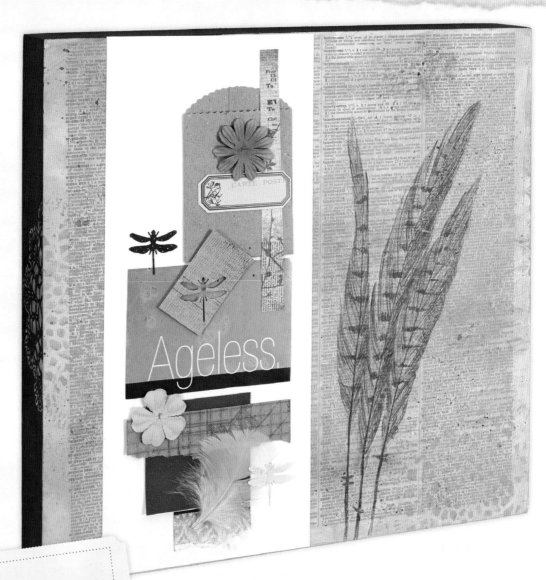

Ageless Beauty

I wanted the focus to be on the collaged "ageless" elements for this piece so I needed something beautiful yet soothing to go along with it. Feathers are a symbol of beauty and grace to me so I knew they would work perfectly with the calming art. I chose a muted color and simple background to showcase the art on top and I couldn't be happier with the results.

Materials

12" × 12" (30cm × 30cm) wood board 6" × 6" (15cm × 15cm) Finnabair Elementals doily stencil

9" × 12" (23cm × 30cm) Strathmore mixed-media paper

black transfer paper

brushes: ¾-inch (19mm) eash, 1-inch (25mm) wash, ½-inch (13mm) DM stippler, no.16 shader

collage elements—paper ephemera

DecoArt acrylic paint in Fawn, Gingerbread,

Traditional Raw Umber, Warm Neutral

dictionary pages

feathers template

Krylon Workable Fixtif

matte medium

old toothbrush

Prismacolor Colored Pencils in Dark Brown, French Grey 90%, Sandbar Brown, Sepia

ruler

sandpaper

scissors

spreader

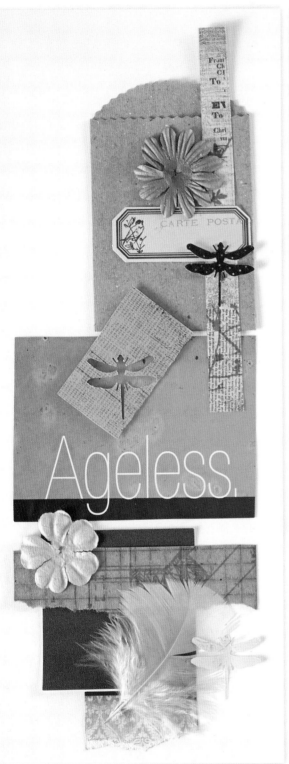

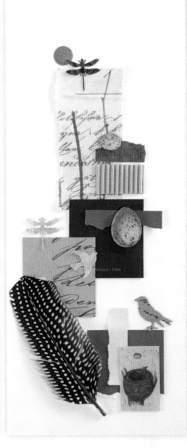

1 Create a Collage on Paper

Create a collage on a vertical sheet of paper. I like to create several of these to have on hand for use in other artworks. For this piece I'll be using the collage on the left.

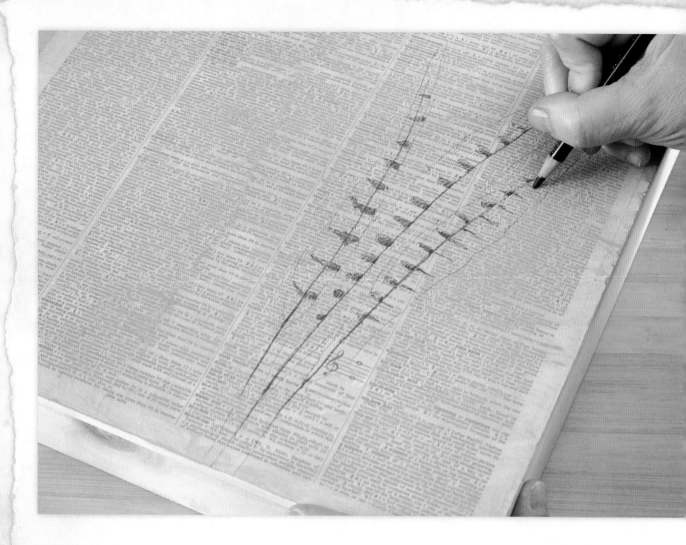

2. Create the Background with Paper
Sand the board well going with the grain. Adhere one dictionary page at a time to the board using matte medium. Smooth the paper using a spreader, starting at the center and working outward. Once the pages have dried, apply a coat of matte medium over the whole board.

3. Add Paint to Integrate
Paint one watery coat of Warm Neutral across the whole board. Make sure the paint is uneven and blotchy to give texture. Paint the edges of the board with Traditional Raw Umber and a ¾-inch (19mm) wash brush.

4. Draw the Feathers and First Colors
Divide the box in half and copy the feathers from the template on the right-hand side of the box using black transfer paper.

Fill the veins of the feathers and black spots using Dark Brown.

Fill the rest of the feathers with circular strokes of Sandbar Brown.

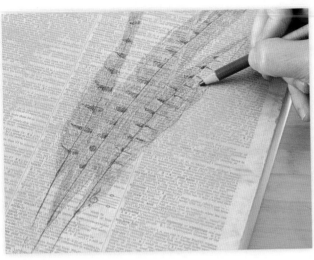

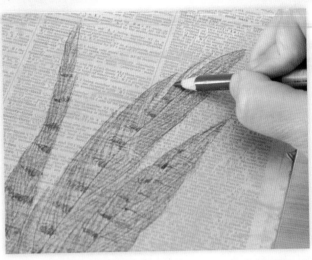

5 Deepen the Colored Pencil Values

Working one feather at a time, use a very sharp Sandbar Brown to create the lines of the feathers outside the dark spots. Be sure to make the lines curved with the shape of the feather and not straight from the vein to the edge. Add as many as possible to make the feather look realistic. In the dark spots use Dark Brown to make sharp fine lines that match the curve of the feather.

With a very sharp French Grey 90%, shade around some (but not all) of the fine lines you just created to give the feather dimension. If you add shading around all of them, it will look too uniform and unnatural.

6 Add Shading to Make Each Feather Unique

With circular strokes of Sandbar Brown, shade the area behind the front feather to show that it overlaps the second feather. Do the same where the middle feather overlaps the back feather.

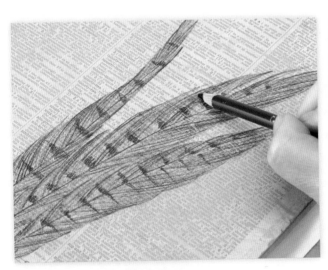

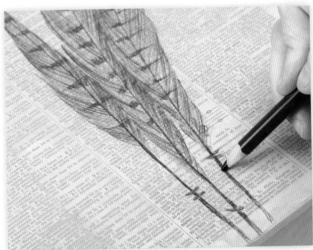

7 Deepen Shading Further

Deepen the shading using Sepia. Deepen the color of the vein of the feathers near the base with French Grey 90%.

8 Add Colored Pencil "Staples"

Make the feathers look like they're attached to the board with small staples using Sandbar Brown. Shade the staples with a line of French Grey 90%.

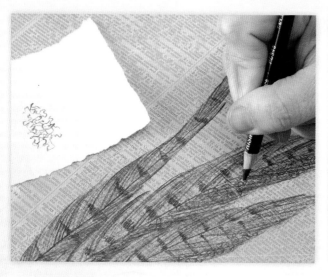

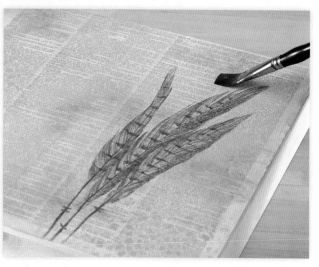

9 Add the Darkest Colored Pencil Values

On the right side of the middle feather, make some scribbles with Dark Brown. Add more scribbles to the outer fourth of the right feather.

Using circular strokes of Sandbar Brown, add the downy feathers at the bottom of the feathers.

10 Add Paint to Integrate

Use a DM stippler brush to add Fawn painted doily stenciling to selected areas of the dictionary page background. Have the stenciling go over the edge of the piece to the Traditional Raw Umber. Add shading using Gingerbread in various places.

11 Spatter Darker Paint

Spatter Traditional Raw Umber on the piece using an old toothbrush.

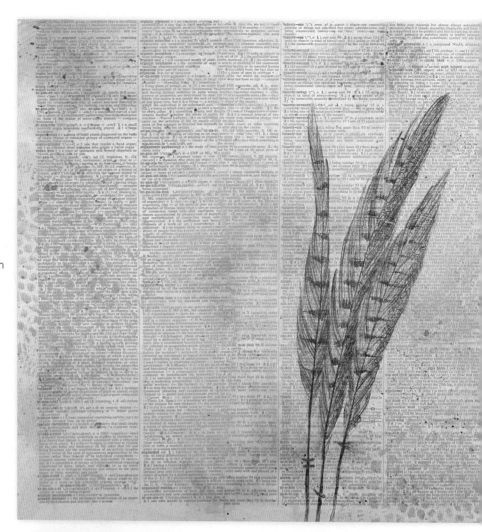

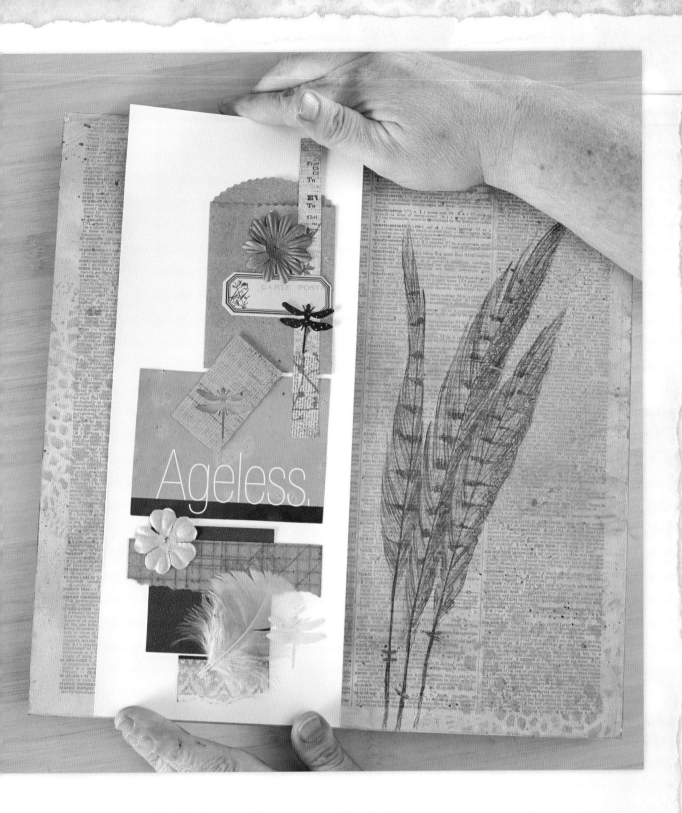

12 **Adhere the Collage Element**
Adhere the collage piece to the left side of the board using
matte medium. Spray the piece with a fixative to seal.

Templates

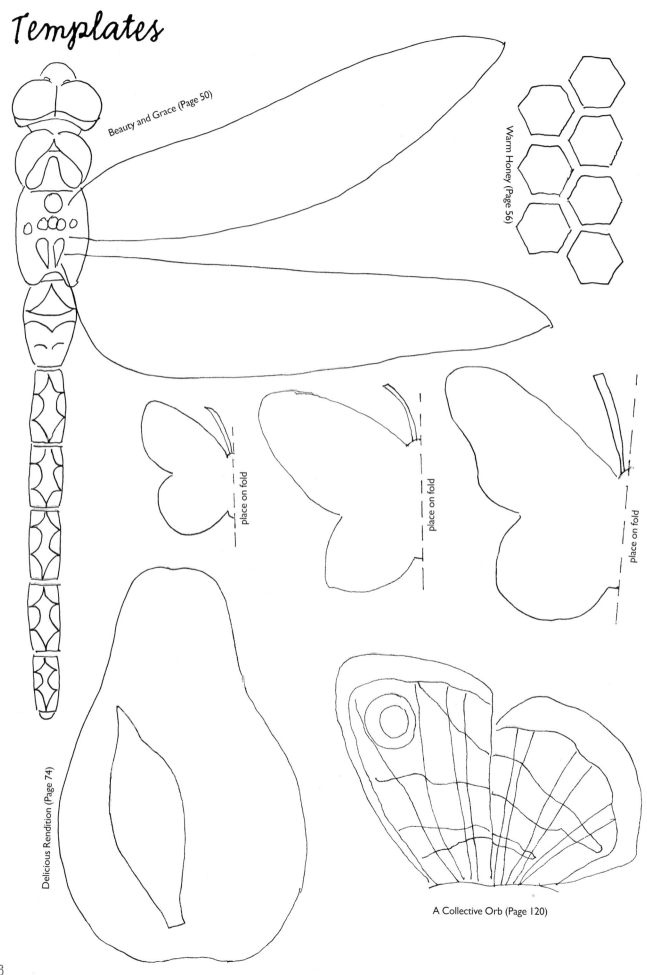

Beauty and Grace (Page 50)

Warm Honey (Page 56)

place on fold

place on fold

place on fold

Delicious Rendition (Page 74)

A Collective Orb (Page 120)

136

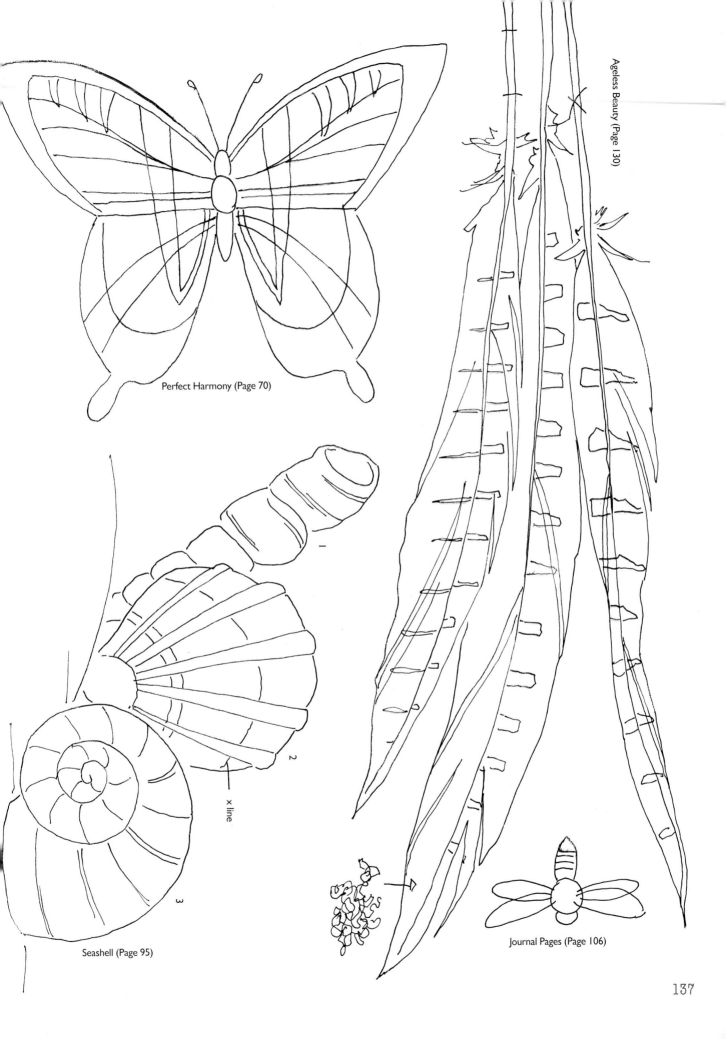

Perfect Harmony (Page 70)

x line

Seashell (Page 95)

Journal Pages (Page 106)

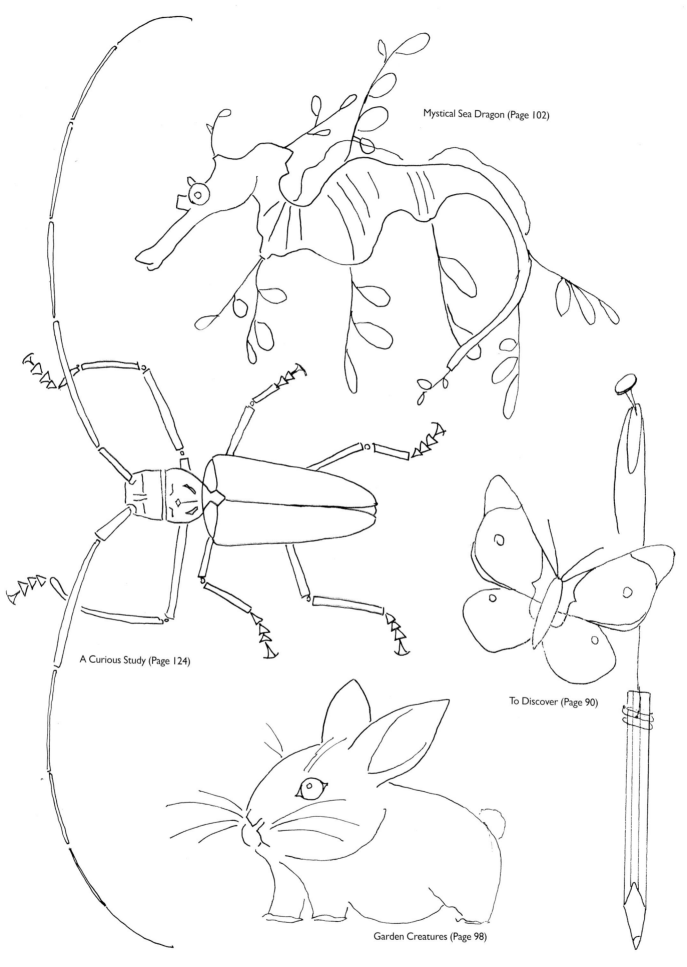

Mystical Sea Dragon (Page 102)

A Curious Study (Page 124)

To Discover (Page 90)

Garden Creatures (Page 98)

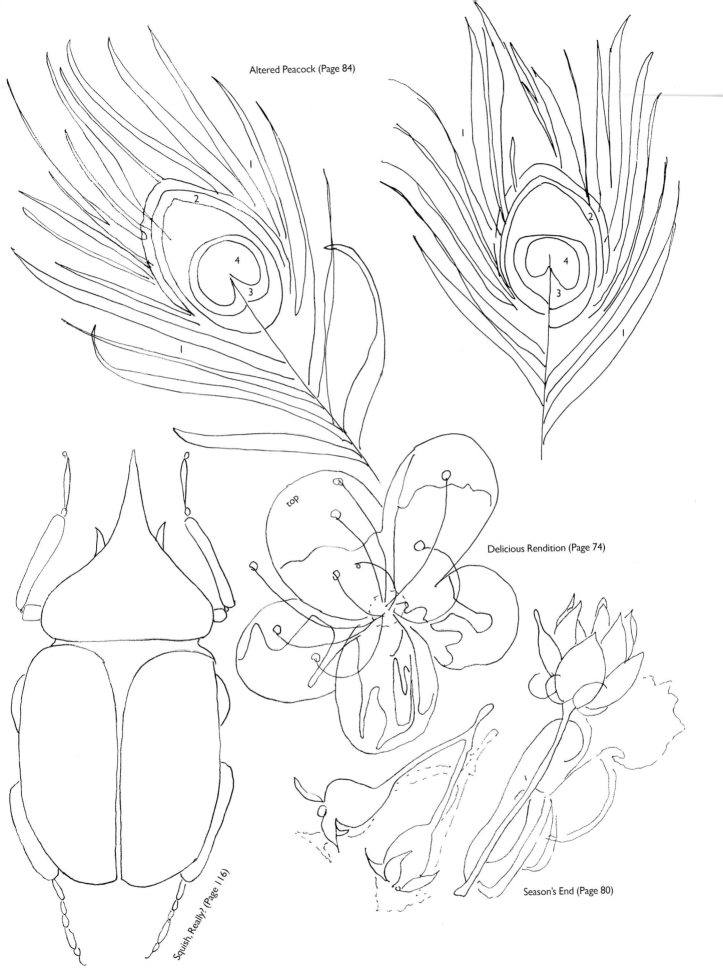

Altered Peacock (Page 84)

Delicious Rendition (Page 74)

Season's End (Page 80)

Squish, Really? (Page 116)

Index

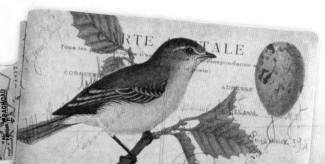

Other fine North Light Books are available from your favorite bookstore, art supply store or online supplier. Visit our website at fwcommunity.com.

a content + ecommerce company

19 18 17 16 15 5 4 3 2 1

DISTRIBUTED IN CANADA BY FRASER DIRECT
100 Armstrong Avenue
Georgetown, ON, Canada L7G 5S4
Tel: (905) 877-4411

DISTRIBUTED IN THE U.K. AND EUROPE
BY F&W MEDIA INTERNATIONAL LTD
Brunel House, Forde Close, Newton Abbot, TQ12 4PU, UK
Tel: (+44) 1626 323200, Fax: (+44) 1626 323319
Email: enquiries@fwmedia.com

DISTRIBUTED IN AUSTRALIA BY CAPRICORN LINK
P.O. Box 704, S. Windsor NSW, 2756 Australia
Tel: (02) 4560-1600; Fax: (02) 4577 5288
Email: books@capricornlink.com.au

ISBN 13: 978-1-4403-3839-7

Edited by Amy Jones and Brittany VanSnepson
Designed by Laura Kagemann
Production coordinated by Jennifer Bass
Photography by Christine Polomsky

Dedication

This book is dedicated to all the wonderful students who I have been lucky enough to cross paths with. Thank you for being part of my life's artful adventure!

Acknowledgments

To my husband, John, who has been there every step of the way for over 34 years. You are my rock!

To my mom, Kae, for endless support whenever needed. Also for experiencing Europe with me and having a couple of our dreams come true—it was truly remarkable to share the journey with you!

To my friends Cassie, Mary, Jan and Cindy—art and you are such a sweet spot in my life. Thank you for being there with support, encouragement and some crazy ideas when needed!

To the North Light team: Tonia, for suggesting this wonderful book concept. Amy, for helping me bring my ideas to life. Christine, for the amazing action shots. Laura, for the design. Brittany, for taking the book into the final stages of life.

It takes a village to succeed. Thank you all for being that village!

Metric Conversion Chart

To convert	to	multiply by
Inches	Centimeters	2.54
Centimeters	Inches	0.4
Feet	Centimeters	30.5
Centimeters	Feet	0.03
Yards	Meters	0.9
Meters	Yards	1.1

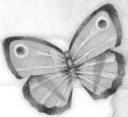

About the Author

I have been an artist my entire life. It started with that wondrous box of crayons, and today it is still challenging me to grow, discover and explore anything that fascinates my creative side. I have been an artist full-time for the past 15 years leading me through the adventure of designing patterns, books and magazine articles, as well as exhibiting and teaching throughout the United States. Online teaching has opened up a new international world, one I am excited to explore.

Never one to stay idle for too long, I have pursued pen and ink, drawing, acrylics, colored pencils, mixed media, photography and writing. It has been a wonderful journey so far, and I cannot wait to see what the muse throws my way next.

Inspiration

For me it comes from everywhere. Nature mostly and it could be the way the light comes through a window, raindrops on a blade of grass, or a bumble bee caught in the crab apple blossoms. Words also thrill me beyond belief. If I hear one I like (at the moment it is *serendipity*), I think about what it would look like in an art piece. Believe me, a dictionary and thesaurus are always close by.

Visit Kelly

Website: www.KellyHoernig.com
Facebook: www.facebook.com/kellyhoernig.artist
Facebook Group: art aMUSEment
Pinterest: www.pinterest.com/kelh2
Vimeo: www.vimeo.com/kellyhoernig
Blog: www.kellyhoernig.blogspot.com
Instagram: kellyhoernig.artist

What You Might Not Know About Me...

I have a very curious nature. Work best by moonlight. Create because I have to. Am inspired by the details. Chase the muse everywhere. Excited by nature. Love a challenge.

My favorite quote is by Henry Miller: "The moment one gives close attention to anything, even a blade of grass, it becomes a mysterious, awesome, indescribably magnificent world in itself."

Ideas. Instruction. Inspiration.

Receive FREE downloadable bonus materials when you sign up for our free newsletter at CreateMixedMedia.com.

Find the latest issues of *Cloth Paper Scissors* on newsstands, or visit ClothPaperScissors.com.

These and other fine North Light products are available at your favorite art & craft retailer, bookstore or online supplier. Visit our website at CreateMixedMedia.com.

Follow North Light Books for the latest news, free wallpapers, free demos and chances to win FREE BOOKS!

Get your art in print!

Visit **CreateMixedMedia.com** for up-to-date information on *Incite* and other North Light competitions.